Beginning Again

Beginning Again

Reflections on Art as Spiritual Practice

DEBORAH J. HAYNES

CASCADE *Books* · Eugene, Oregon

BEGINNING AGAIN
Reflections on Art as Spiritual Practice

Cascade Books
An Imprint of Wipf and Stock Publishers
199 W. 8th Ave., Suite 3
Eugene, OR 97401

www.wipfandstock.com

PAPERBACK ISBN: 978-1-5326-3940-1
HARDCOVER ISBN: 978-1-5326-3941-8
EBOOK ISBN: 978-1-5326-3942-5

Cataloguing-in-Publication data:

Names: Haynes, Deborah J., author.

Title: Beginning again : reflections on art as spiritual practice / Deborah J. Haynes.

Photographs by Valeri Jack, Chris Lavery, Cynthia Moku, Kenneth O'Connell, Rayna Manger Tedford, Norman Weinstein, Jeff Wells, and Deborah J. Haynes.

Description: Eugene, OR: Cascade Books, 2018. | Includes bibliographical references and index.

Identifiers: ISBN 978-1-5326-3940-1 (paperback). | ISBN 978-1-5326-3941-8 (hardcover). | ISBN 978-1-5326-3942-5 (ebook).

Subjects: LCSH: Mysticism and art. | Creation (literary, artistic, etc.). | Art—Problems, exercises, etc. | Ritual in art. | Art and religion. | Spirituality.

Classification: N72.M85 H34 2018 (print). | N72.M85 (ebook).

Manufactured in the U.S.A. SEPTEMBER 17, 2018

In homage to my teachers

Contents

CONTENTS

Preface

WHAT DOES IT MEAN to be an artist? How might artistic practice become an expression of spiritual life? Perhaps the most fundamental human question is, how should one live? These questions point toward the values that guide our daily lives—values that may range from cultivating mindfulness, kindness, and compassion toward others to acquiring fame and wealth in the art world.

In the end, I am drawn to historical and contemporary traditions of art-making that embody what Paul Klee called "visualizing the invisible." How one conceives of this invisible is crucial. Is it an entity or void, presence or absence, form or emptiness? Here I seek to give form to challenging ideas: impermanence, suffering, and the inevitability of death; the virtues of generosity, kindness, and compassion; and more abstract concepts such as negative capability and groundlessness. I invite you to enter into an inquiry with me focused around such issues and questions.

Derived from the Latin *ars*, "skill or craft," *art* is an especially multivalent word. It names human activity in the world, often contrasted with the natural world. Art is usually associated with the creation of beauty, but it can also be grotesque, ugly, or even violent. We build and construct artifacts with physical materials, but also with sound, color, movement, and language. Here my focus is the visual arts. I believe that making and looking at art can be a form of contemplative practice, a space in our noisy and information-saturated lives for solitude, silence, and being in the present. Like prayer and formal meditation, art can become part of the foundation of who we are in the world, as intrinsic to our nature as breathing. Traditional Tibetan Buddhists considered artistic work as spiritual practice and art itself as an expression of spiritual power. I share this understanding of the efficacy of art.

Although I certainly hope that this book will be accessible to a wide range of readers, it is grounded in Buddhist ideas and values. For Buddhists, spirituality is the process of getting to know the mind and taming it. Buddhism is, first of all, a path of self-reflection, of looking without bias or judgment at what arises in our perception and experience, thoughts and feelings. Its foundation is the historical Buddha's teaching on the Four Noble Truths and the Eightfold Path. In all of its cultural manifestations, Buddhism holds the view that all sentient beings desire happiness and freedom from suffering. Humans suffer in so many ways, but especially from our ignorance, greed, and hatred. Based on fundamental values of altruism and kindness, Buddhist practice is a path of finding out for oneself, through study, meditation, and service, how to live and how to prepare to die. In other words, Buddhism is both a philosophy of life and a practical path, a set of skillful means for attaining the goal of enlightenment in this life or in lives to come.

Beginning Again is a personal statement, born from my experience as an artist, writer, and teacher. Each chapter begins with short prescriptive reflections. Within the book as a whole, they constitute a manifesto, a declaration of the questions and values that guide my life and creative work. And like all manifestos, this is not a neutral tome, but a personal plea for an engaged artistic practice that is spiritually and intellectually grounded. I know that there are competing views about art and spiritual life. I do not wish to be doctrinaire or dogmatic, but this is what I believe.

Not long ago, as I was reading a book by architect Nader Khalili, I was struck by his comments regarding vocation: "Midway in my life, I stopped racing with others. I picked up my dreams and started a gentle walk . . . I touched my dreams in reality by racing and competing with no one but myself."[1] I too am attending to my dreams and my vision, racing and competing with myself. But perhaps this image is too strong. I am not in a competition. Instead, I am trying to slow down, which is why Khalili's image of a gentle walk touches me. As an artist, I seek to maintain a contemplative pace and create art that reflects my Buddhist path and practice. This is my story, a story of endings and beginnings. Here I begin, again.

1. Khalili, *Racing Alone*, vii.

Acknowledgments

WRITING, FOR ME, IS always a dialogue: a dialogue with the past, present, and future; a dialogue with faces and places; a dialogue of heart and mind, or perhaps more accurately, of body, mind, and spirit. I am filled with gratitude, especially for all the readers who have engaged with my writing over several decades.

Beginning Again: Reflections on Art as Spiritual Practice has had a long trajectory dating back to the late 1990s. After publishing two academic books with Cambridge University Press, I decided to bring a more personal voice into my writing. My first venture in this direction was *Art Lessons: Meditations on the Creative Life*, published by Westview in 2003. Although it still circulates, that book later went out of print. Sarah Warner, the original editor, helped me to acquire the copyright in 2014, for which I remain deeply grateful. Because it forms the core of this book, readers familiar with *Art Lessons* will find similarities and striking differences here.

Over the years, much has changed. *Beginning Again* might be read as a sequel to *Book of This Place: The Land, Art, and Spirituality*, published by Pickwick Publications in 2009. The site I focused on was radically altered by massive floods in 2013, and the present book describes what happened. More significantly, my exploration of Buddhism, which began in 1975 when I was introduced to zazen, deepened slowly until 2005, when I met the Venerable Dzigar Kongtrül Rinpoche. Since then, my meditation practice has stabilized and intensified, with regular daily practice and yearly one-hundred-day retreats. Synchronous with this, my studio art practice has become an essential dimension of my spiritual life. While I sometimes feel this is heretical, it is the path I explicate in these pages.

I dedicated this book to my teachers, all of whom are named in what follows. But I must acknowledge here the Venerable Dzigar Kongtrül

Rinpoche and Elizabeth Mattis Namgyel, each of whom continues to teach me so much. The Mangala Shri Bhuti sangha, which Kongtrül Rinpoche founded, provides inspiration on many levels for both my spiritual and artistic lives. To all of you across the globe I bow.

I bow to the members of my family, friends, and colleagues who recently read book chapters: Virginia Abblitt, Peter Aucott, Katie Atherton, Frank Burch Brown, Marie Cannon, Wendy Conquest, Mary Covell, David Croke, Katy Diver, Paula Fitzgerald, Douglas Frank, Lee Gass, Sue Hagedorn, Catherine Haynes, Stephanie Hilfitz, Chris Holland, Olivia Hoblitzelle, Benjamin June, Mary Lee Mooney, Ann Thomas, David Thorndike, Helen Turner, Clarke Warren, and Joseph Waxman.

I bow to the dedicated care team that helps with my husband, David, and with the household, and which supports my regular yearly retreats: Helen Turner, Catherina Pressman, Mark Wischmeyer, Douglas Frank, and Clarke Warren. Since moving nearby, David's daughter, Leslie Thorndike, and son-in-law, Jimmy Goetz, have joined this circle of care. And I bow to the many friends in Jamestown and Longmont, Colorado, who continue to enrich our lives by providing a strong sense of community.

The production of the book has been a writer's dream. Melanie Mulhall of Dragonheart offered her brilliant editing skills, and Rivvy Neshama proofread the text. In the final stages of preparing the book for Cascade Books, Melanie, Rivvy, and I have been like the Three Graces, Greek goddesses of charity, beauty, and creativity. I bow to photographer Rayna Manger Tedford of Crystal Lotus Studio, who photographed my art and prepared the photographs for publication.

The staff at Cascade Books have proven their mettle over and over again, especially K. C. Hanson, editor in chief; James Stock, director of marketing; Matt Wimer, assistant managing editor; and the staff who helped bring the book to fruition, especially Heather Carraher, Jeremy Funk, Brian Palmer, Shannon Carter, and Daniel Lanning. To all of you I bow.

Yes, this book is a dialogue in every way.

Illustrations

Photographs by the author unless otherwise noted.

1

The Artist

> ➤ *To contribute toward the future, the artist must have a compassionate spirit, keen intellect, and strong body, as well as developed inner vision and far-reaching outer sight. Keep your eye simultaneously on your next step and on the long horizon.*

> ➤ *Cultivate stamina, for the artist's vocation is strenuous. It is not for everyone.*

ARTIST IS WHAT I call a five-dollar word. Unlike cheap ten-cent nouns such as *car* or *cookie*, *artist* is a big word. It can be full of pretension, or it can carry profound resonance. In an attempt to counter the pretenders, poet Carl Sandburg reputedly said that *artist* is a praise word, a designation that should only be applied by the community to a select few who embody certain accepted ideals. The national poet laureate and the Japanese potter identified as a national treasure are artists because they are recognized within their national communities. Only a few people can be true artists from this perspective.

Artist Joseph Beuys took an opposite approach in defining who could be an artist. Based on his lifetime of innovative creative work, Beuys repeatedly said that everyone is an artist. Art is not the special province of the cultural elite, defined by an even more elect few, but an arena open to all. In today's world, Beuys's definition is much more compelling than Sandburg's. Like Beuys, I believe that artists are not born with special talents,

though some people do have inherent gifts and proclivities that would seem to make their learning easier. Regardless of such gifts, I am convinced that artists are made primarily out of intention, imagination, and creative action, so if you want to be an artist, develop your aspiration first. Practice will follow.

To be an artist means *doing everything as well as you can*. I first learned this phrase as a young student from art educator Tom Ballinger. He told us that in practicing their arts, the Balinese would say, "We have no art. We do everything as best we can." This idea has long had veracity for me, and in our present cultural context, where the production of art for gain, fame, and consumption dominates, such an idea suggests another range of possibilities. All the acts of daily life are an arena for the aesthetic if we use this broad definition.

What do you feel called to become or do in the world? Another way to ask this is, what is your *vocation*? This is not a frivolous question, for the concept we hold of our work profoundly affects what we create. The word *vocation* has a complex history that reflects cultural changes over nearly two thousand years. Consequently, its meaning has evolved dramatically. The Latin *vocatio*, which means "a call," had a distinctly Christian tenor and referred to grace from God and renunciation. For early Christians, it was blended with the idea of a special religious profession based on aptitude and right intention. But the medieval mystic Meister Eckhart suggested that this notion of a call from God should be independent of the monastic life and entrance into a religious order. He claimed that secular work, such as serving the needy, could be the arena for one's *vocatio*. In the sixteenth century, Martin Luther helped to effect a complete reversal of the term's original meaning when he asserted that only through work in the world could one realize a calling from God. Today, the word *vocation* is virtually synonymous with "job" and "labor for pay."

It is worthwhile to study the implications of that history when considering your own role as an artist. Artists serve and have performed many functions in cultures around the world and across time, from artisan and civil servant to entertainer, illustrator, genius, hero, creator of consumer goods, healer, critic, prophet, and visionary. Over many years of study and writing about this, I have concluded that there is a great need for artists who can cultivate their visionary imagination as well as their critical and prophetic faculties.

What if the artistic vocation were seen as a special profession based on right intention and right livelihood? What if artists were to reclaim some of the earlier resonances embedded in the word *artist*? What if artists took their vocation as seriously as those in the twelfth century who devoted their lives to the service of others? This would shift the attention and weight we give to our work and would result in a new art.

A unique way of conceptualizing the artist's work was suggested to me by Hannah Arendt's discussion of labor, work, and action. All three might be understood as categories for describing particular kinds of art. Artists *labor* in cyclical and repetitive processes to produce the artifacts needed to feed, shelter, and clothe both family and community. The gardener, weaver, and potter labor to create what we use each day. Artists *work* to create material objects that we live with in our daily lives. Paintings, prints, or sculptures that enhance our surroundings might be seen as the result of such work.

Action refers to another level of activity, a new conceptualization of the art-making process. Art as action seeks to establish new self-other relationships in this mysterious and interdependent world that is the context for all of life. To understand art as a form of action means that there is less concern with consumable products, though they may result from creative processes. The artist who engages in such creative action may or may not choose to make objects. But to paraphrase Arendt, the most important thing is to think what you are doing.

But where might you find inspiration as an artist? Having had the opportunity to study and teach about the arts of diverse world cultures, I am fascinated by artistic practices and views of the artist that emerged within Native American traditions, such as the Navajo and Haida, and within Greek and Russian Orthodoxy, Islam, and Himalayan Buddhism. All these traditions link the artist to religious life, and I have been most curious about similarities between Orthodox and Buddhist approaches to making art.

Regardless of their background, Orthodox icon writers (painters) and Buddhist thangka painters work under canonical authority and strong artistic tradition. Technical aids to painting include fixed patterns, spray stencils, imprints, illustrations in manuscripts, block prints, texts (especially when a life history is to be portrayed), and painter's manuals containing further data about color and other details. Nevertheless, opportunities for

individual expression can still be found in the design and decorative details, such as landscape and ornamentation.

Beyond these technical issues, the thangka painter or icon writer is urged to embody certain personal qualities, including restraint, compassion, patience, and little concern for wealth. Such a painter should be scrupulous in conduct and able to work in a sustained manner without procrastination. When a thangka or icon is completed, the painter must be able to explain it clearly to the patron, which means that the artist must have a strong understanding of religious tradition. In both historical and contemporary settings, there is little place for the kind of individual artistic expression that characterizes post-Renaissance Western artistic traditions

The dialogue of religious aspiration and artistic practice that continues to shape such traditions has provided me with alternative models for rethinking my own creative process. I offer these introductory definitions of the artist from American, European, Balinese, Himalayan Buddhist, and Orthodox Christian cultures as a way of opening up the question of who and what an artist might be. The main point is to reflect critically about what direction your own calling toward the arts might take. To be an artist means integrating heart and hands, body and soul, mind and spirit. To be an artist means integrating one's art and one's life.

How will you cultivate the stamina for this complex task? Common sense suggests paying attention to diet, exercise, and sleep. Most of us know the importance of these aspects of daily life that enhance stamina, but we often fail to implement processes of self-care, especially when caring for others or in contexts of demanding work. Yes, physical stamina is a crucial part of this process, but so is self-reflection and the discipline to carry out and give form to our aspirations. All dimensions of our being are called forth in this process, including the mind and intellect, as well as the five senses.

In particular, our capacity for inner vision—for fostering insight, imagination, and the ability to visualize—is directly linked to how we use outer sight and the other senses. In the era of the screen many of us are myopic. Learning to extend outer vision is an antidote for this. I recommend that you actively seek opportunities to look into the far distance, at what I call the "long horizon." Of course, this phrase carries both visual and conceptual implications, for we can also think about the long horizon of a lifetime with its many journeys and byways. I love to stretch my own gaze

by looking into the far distance on a clear day or by lying on the ground to observe clouds.

Many skills will help you bring the arts into your daily life and make life itself an arena for aesthetic and ethical acts. Here, at the outset of the book, I ask you to reflect about such issues related to what it means to be an artist and how to deepen your artistic intention and experience. Drawing, writing, and reading are among the most basic prerequisites.

2

Drawing

➤ *If you are an artist or aspire to become an artist, cultivate your eye-hand coordination by looking at the world and by representing what you experience.*

➤ *Create your own challenges and follow through. Draw to give your self-reflection visual form.*

YOU MAY FIND IT curious that I emphasize drawing so early in this book about art and spirituality. In contemporary American society, we often hear that students must learn the basics—reading, writing, and arithmetic— with the assumption that reading comes first. Somehow, we are led to think that reading is a prerequisite for all other intellectual endeavors. I disagree with this assumption. Before they could read, human beings made marks. And I concur with sculptor David Smith's assertion that drawing, as a form of mark-making, came first in human experience, even before song. Writing is also a form of mark-making, and reading can teach us to create more complex marks. It is probably a fallacy to assert that one activity is preliminary to another, but I know, through my own experience and through extensive teaching, that drawing, writing, and reading nurture each other.

In my studio practice, I draw from life—the human figure and objects such as tractors or a bulb of garlic. I draw my nighttime dreams. I love to draw natural phenomena, so I draw, or try to draw, a moving creek, clouds

skimming through a cerulean sky, and snow landing on dandelions that have just opened. I draw using language, reciting prayers while forming the letters with graphite and colored crayons. I have long worked on developing what I call an "iconographic language," a set of symbols unique to my experience. Having studied symbolic systems of diverse peoples around the world—and forms of their art such as Buddhist thangkas, Russian Orthodox icons, Navajo rituals and sandpaintings, Islamic manuscripts such as the *Shahnameh*, and Indian manuscripts such as the *Devi Mahatmya*—I am fascinated by the meanings associated with numbers, colors, and cultural symbols. In particular, trying to find or create adequate symbols to visualize my daily meditation practice remains a task that I embrace with enthusiasm. You might experiment with some of these types of drawing for yourself.

Since my years as a college undergraduate, I have taken and taught many drawing classes. I vividly remember my first experience in a summer drawing course during which we drew for four to five hours each day from the model, from still life tableaux, and outdoors. I learned so much that summer, and I highly recommend such intensive periods of drawing practice. In teaching drawing, I successfully used Betty Edwards's 1979 book *Drawing on the Right Side of the Brain* to help student artists confront their fears about drawing from life. Compiled by Anna Held Audette, *100 Creative Drawing Ideas* is a valuable compendium of exercises that will inspire both aspiring and mature artists.

Of course, you may be interested in using digital media, tablets, and other technologies to draw and render images. But I urge you to spend some time working directly with your senses in nature—looking and seeing, listening and hearing, touching—and then representing what you experience. Early twentieth-century artists such as Vassily Kandinsky created stunning paintings and drawings based on synesthesia, integrating multiple senses in the creative process.

I also recommend drawing contour portraits. I teach students blind contour drawing with their classmates as a way to learn how to observe with an attitude of deep respect. Described in detail by Kimon Nicolaïdes in *The Natural Way to Draw*, contour drawing involves trying to focus the attention, to merge touch and sight. The practice is to move the eye along with the pencil, keeping the body relaxed, and not looking at the paper. The most difficult part of the exercise for most students is to resist worrying about the outcome. Students work in pairs, where one student is the

"artist," the other the "model." Then they reverse roles. Usually I start with one-minute timed portraits. Depending upon student engagement with the exercise, I may repeat it several times, with students changing partners and lengthening the amount of time for each round. As they cultivate respect for one another through this exercise, I hope to awaken a greater sense of regard for the art we study. Learning to look at works of art with regard and copy them can also be a new and profound experience, given that most of us take so much of visual culture for granted.

FIGURE 1

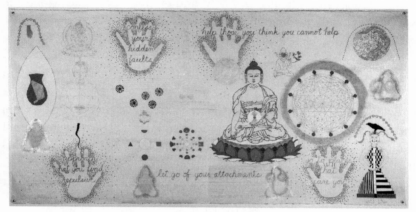

I experimented with these and other techniques in 2006 when I held a residency at the Morris Graves Foundation in Loleta, California. Founded after artist Morris Graves died, the foundation is located at a site called The Lake. At the center of The Lake campus artists live and work in buildings, including Graves's studio, that surround a lake. For three precious weeks, I drew and painted for long hours each day, expanding on several series I had begun around 2000. A series titled *Marking Time* includes scrolls and drawings done over periods ranging from two weeks to twenty months, and they function simultaneously as maps and calendars. Using recognizable symbols, texts, and my own iconographic language, I literally give form to experiences of space, place, and time.

A series of large drawings titled *Everything I Know* evolved as part of this series. There I sought to represent details of my life, such as everywhere I had lived and traveled, all of the plants in my medicinal garden, and animals I had learned about as a function of their proximity in my town. In this drawing, the third in that series, my Buddhist practice over

two one-hundred-day retreats is depicted. The imagery is complex—with a silver stupa, mantras, visualizations, the five slogans of Machig Labdrön's *Chöd* practice, and white writing that is difficult to see or read. *Everything I Know* is now a new series of its own because it is impossible to give visual form in one drawing to everything I have learned in this life. Nevertheless, I enjoy the impossibility of this challenge.

In the end, to talk about drawing is not my main point here. Don't be seduced by thinking that reading about or talking about drawing is adequate. If I were sitting with you right now as you read these words, I would suggest that you look around to see how you might initiate mark-making in this moment. Resources are everywhere.

Pick up that stick lying on the bare ground and mark the earth. Ah, there's an old book that you might like to alter. That magazine on the table has such thought-provoking cartoons and photographs. Try copying an image from a book about your favorite artist. And yes, there's a blank journal awaiting a mark with your new mechanical pencil. Over years of such experimentation and play with making marks, I have even turned writing into drawing. These are a few ideas, but you must create your own experiments.

3

Writing

➤ *Write to find out what you think. Unless you know what you think, you will always be subject to the will of others, including the media that so pervasively shape contemporary cultures.*

➤ *Try to understand and articulate your motivations and reasons for believing and acting in particular ways. These are compelling reasons to write.*

THE REASON TO WRITE is simple. Through writing, you will learn what you think, and you will come to know yourself. When I write, I listen to inner voices. Sometimes they talk to each other; sometimes they just chatter. But sometimes I am surprised as new perceptions lead to new thoughts and new thoughts lead to new insights. And suddenly I wonder where those insights came from. Writing offers a special kind of access to the spirit, heart, and mind.

I did not grow up writing, though I still remember the joy I felt at age eight when I completed my first two reports, which were on clouds and butterflies. Not until I was a student in ceramics did I begin to keep a journal. And this is a practice I recommend most highly. At first, I simply kept notes about glaze recipes and firing the kilns. Then I began to track my dreams and use my journal to wrestle with both past and present experiences.

Later, while completing my master's degree in studio art, I wanted to redeem the artistic qualities of language, to infuse language with the color

and mystery of other artistic forms. I began to create mixed media drawings with handwritten text. Even then, I was wrestling with a dual identity as artist and writer. "I want to develop a coherent symbolic vocabulary," I wrote in a journal, "an iconographic language. I seek to comprehend the universe, to represent meanings greater than verbal articulation can encompass. These symbols speak of mysteries: of the feminine, of birth and nourishment, of transformation."

Writing had become a way to create a matrix for understanding my identity and what I created. On one small drawing I scribbled my musings: "In writing, I analyze, which means 'to unloose or undo' in Greek. Analysis involves breaking that which is complex into its simple elements, and it is generally deductive. Through writing I extend back into the past, I explore the present, and I reach out into the future. Writing is a way of asking why and how, and of seeing what my experience is." Such texts were integrated with symbols drawn from dreams and reveries, imagery developed into an iconographic lexicon. I pushed at the boundaries of what constitutes art, asking questions about the purpose and function of the visual arts that presaged much of my later writing.

What *kind* of writing would I recommend? If you want to become an artist, your goal will not necessarily be to become an eloquent writer for a public audience. But as my examples illustrate, writing is a powerful method for finding out what you think, which will serve you in musing about your direction and in practical ways, such as preparing artist statements, grants, and residency proposals.

If this path seems of interest to you, I recommend a kind of writing that lies in the interstices between fiction and nonfiction and between memoir and autobiography. Start by writing about yourself. Japanese writers of the early twentieth century called their unique genre the I-novel. In responding to Western notions of selfhood and individuality, both women and men writers created heroines and heroes based on themselves. The oeuvre of Harumi Setouchi, for instance, is considered a powerful example of this genre. Even the work of the well-known novelist Haruki Murakami often uses first-person narratives.

Through writing, you will come to know yourself, so tell your own story and explore your inner voices. You may want to write an account of formative events and their consequences or narrate a particular kind of story about your life that does not purport to tell the entire story of what your life has been. Or you might want to tell the "true" chronological story

of what has happened. But this idea that there ever is a single truth has been radically questioned by contemporary theorists who claim that truth is a conditional concept, dependent on many factors and perspectives. In art, as in life, we may attempt to tell the truth, but we still invent coherence. In telling your story, do not be surprised if you find yourself fabricating pieces of the puzzle.

Writing brings attention to the complex interrelationships of selfhood, authorship, and representation. Using a genre that transgresses the boundaries between fact and fiction, you can begin to understand that the self is not individual and unique but develops in ways that are closely articulated with the lives of others. The self, like all phenomena, is interdependent. Authorship and creativity, then, take on new meaning. Certainly, it is usually a single hand that marks and writes. But the self is so enmeshed with the lives of others, and meaning derives from this complex intertextuality, the nexus of relationships that comingle during a lifetime. How could I narrate significant parts of my life, for instance, without talking about specific mentors, teachers, members of my family, and friends? They inhabit my conscious life, my heart, and my mind. Writing about them—representing them—is part of the effort to make the absent more present and the invisible visible.

Inevitably, an element of fiction enters this process because representation exists symbiotically with one's lived life. You may imagine that your life progresses in a linear fashion and that chronology is the most useful means for understanding the joys and sorrows of your experience. Linear narrative and chronology are certainly crucial characteristics of fiction. But ask yourself, where does the boundary really lie between fact and fiction? Try to tell your story directly, with an ear and eye to the objective accuracy of the events you relate. But remember that objectivity is a myth because experience is inherently subjective. My fact may be my sister's fiction because experiences of time and memories are unique for each of us.

In practical terms, how might you begin to write? Write about your past, your dreams, and your present experience. Describe key relationships, places, and world events. Everything is suitable. Your age doesn't matter because we have all had formative experiences worthy of description. People write memoirs not because their lives are finalized, but because enough has happened to make it worthwhile to reflect about the process of past evolution and future transformation.

If you are interested in reading others' efforts, try books such as James McBride's *The Color of Water*, G. H. Hardy's *A Mathematician's Apology*, Mary Karr's *The Liar's Club*, Margaret Miles's *The Long Goodbye*, Alix Kates Shulman's *A Good Enough Daughter*, or Tom Wolfe's *Electric Kool-Aid Acid Test*. If you are older and dealing with issues around aging, illness, and death, I recommend Katy Butler's *Knocking on Heaven's Door* and Olivia Hoblitzelle's *Ten Thousand Joys & Ten Thousand Sorrows*.

Like some of these writers, you might develop narratives that are thematic rather than chronological, and discontinuous rather than linear. Try writing about rain or blistering heat, the sky or the sea. Describe particular experiences with the elements using all of your senses. Reject what might be called the "spotlight approach" that focuses on yourself as a single unique subject. Turn instead to questions of context and social location, to your position within social networks, including your family and communities such as your sangha or religious congregation, school or workplace. What is happening in the wider world right now? How do these events affect you?

Recognize the contingency of facts and arguments, a natural result of acknowledging your unique standpoint in the world. I, as writer, and you, as reader, each occupy a unique time-space nexus. This particularity thoroughly influences how we see and act. When you write, recognize that no one else will see the world quite like you do. To develop an understanding of this, try writing a description of an event from another person's point of view. What if you wrote about your life as though you were the opposite sex? Consider the ways gender and social conditioning influence writing. How might these factors change your sense of things?

Depart from realist principles and practices by disrupting chronology, by disputing fixed notions of sex and gender as well as of reality itself, and possibly by confounding the certainties of readers. Recently, I was riveted for days as I slowly read Ruth Ozeki's *A Tale for the Time Being*. By her own description, Ozeki wrestled with this book for many years, working intensively, then abandoning it, and finally bringing it to fruition. Her masterful disruption of the narrative and her integration of Zen Buddhism with environmental awareness of events such as the Fukushima nuclear disaster created a gripping multilayered story. Although its main characters are a suicidal teenage girl, a 104-year-old Zen nun, and a novelist with writer's block, it is Ozeki's I-novel. Her book is powerful proof that life is never linear and straightforward.

As you take on and develop your own writing exercises, you will see that writing raises complex psychological questions about the nature of the self and authenticity. Each of us is defined through relationships to places, events, and persons. This interdependence is formative in developing your sense of self. And certainly, writing can be a form of spiritual practice, as Robert McDowell's *Poetry as Spiritual Practice* demonstrates.

Ask yourself what kind of writing best serves your needs. As a writer, you will inevitably engage in multiple interpretive acts. Similes and metaphors, for example, inform the essential quality of any narrative and can be used to make your writing more vivid. Consider the simile "the world is like a forest" and contemplate how life is a process of making your way through that forest. As sojourners, we sometimes travel on already existing paths—and sometimes, we create our own. We come to a clearing, stop and rest, cultivate the land, and build a structure in which to live. Sometimes wandering in the forest leads you back to a familiar crossroad. Often, you encounter the unknown, the unexpected. Dangers lurk, especially if you do not know basic survival techniques.

Such a benign simile results in a completely different narrative than another image, such as "the world is like a battleground," a site where we risk our lives repeatedly, conquer enemies and demons, and wrestle with angels and devas. For me, the world is more like a forest, full of risk, danger, and potentiality, a place where struggle is necessary but armed combat is not. Experiment with such similes and metaphors in your own writing.

More than anything else, I urge you to write in a style that is intertextual and polyphonous. Let many voices speak. Concrete events, persons, and conversations of everyday life will form the foundation of your reflection, but your inherent curiosity may take you into the world of ideas.

And what of historical sources? You might try writing with the aid of photographs, maps, and other images. All such sources offer perspectives on given historical moments, but none can be relied on to give a complete picture. Even the acts of rereading what you have written and of looking at old photographs are closely tied to memory. All experience is perspectival and subjective. Your experience depends on your standpoint. Memory helps each of us to shape our orientation toward and vision of life. Without memory, we live in an eternal present, which might sound obvious, but it can also be disorienting. Nevertheless, memory has its limits because the self you imagine and describe is always partial. You may link persons and events to particular feelings in memory that were not connected to the

original experience in the past. Because of that, even historical writers often use the devices of fiction in reconstructing the so-called actual past. In this way, history begins to blend with fiction and new aesthetic issues are raised.

Writing your autobiography or I-novel will most likely not refer to your life in ways that you assume it should. Because memory is selective, because most events and persons in your life are probably forgotten or half-submerged in memory, the process of piecing together memories to form a more or less coherent whole is highly selective. Writing about yourself, whether by setting pen to paper or fingers to keyboard, is a way to begin the process of becoming comfortable with language. To paraphrase Ruth Ozeki, as the heroes of our own narratives, we continually reconceive ourselves. We write ourselves into being, again and again. I am an artist. I am a writer. I am a Buddhist practitioner. I am a sister, a mother, a grandmother. I am none of these and all of these. The possibilities for what Annie Dillard calls "the writing life" are immense, once you have begun.

4

Reading

> ➢ *Read to find out about the worlds of others. Self-satisfied narcissism and ignorance have no place in the life of a serious artist today.*

> ➢ *Read to inform and inspire your life, your writing, and your art.*

> ➢ *The sustained multitasking and continuously interrupted attention of contemporary life often leave us with no time to think and with minds and bodies that are too fast for reading. Consider what you will do about this.*

TO WRITE WELL, YOU must read. Sometimes I think that reading has become an esoteric activity, undertaken by only a few who grew up before the age of the ever-present screen. So I say to you, read indiscriminately and read voraciously. Follow your nose; that is, let your curiosity guide your explorations. Reading is not the same as online surfing and skimming through websites and email. Reading is one method for learning to follow a long thought, to follow the stream of another's consciousness until we understand what that person perceives and thinks.

I am reminded of a story about Karl Marx that illustrates this point. Reputedly, when he began reading the work of German idealist philosopher G. W. F. Hegel, Marx would copy out a paragraph from Hegel's text,

then write his own comments beneath it. I have always found this to be an enormously helpful way to begin writing. Try the exercise that Marx found so rewarding. Select a short text that is difficult but compelling to you. Copy it onto a page. Then write your own reflections about what you have just copied.

Reading is not the sole prerequisite for writing, but it is a powerful impetus, for reading introduces us to the worlds of others. Reading also allows the cadence and structure of another's writing to seep in, and this can make a profound difference in how you think and what you write. Without exaggeration I can say that I have always loved reading. As I child, I read hungrily, picking up whatever was around, reading even at night when I was supposed to be sleeping. As an adolescent, I spent many Saturdays in the local library, reading books that I found there on philosophy, poetry, and psychology. At other times I sat near the bookshelves in my mother's library, with art books and tomes by existentialist philosophers such as Jean-Paul Sartre and Albert Camus. I read periodicals at school on world affairs and participated in debate class during high school. The proliferation of nuclear weapons and disarmament were timely topics, and my political view of the world was formed as I learned about war and weapons of mass destruction.

When I was a high school and college student in the 1960s and 1970s, the civil rights movement was in full swing. As a child in white suburbia, insulated from the experiences of people of color, I gained access to their world through reading. I read John Howard Griffin's *Black Like Me*, *The Autobiography of Malcolm X*, the poetry of Langston Hughes, and novelists Richard Wright and James Baldwin. Like many others, it took years before I would read Toni Cade Bombara, Zora Neale Hurston, Paule Marshall, Toni Morrison, Alice Walker, and Margaret Walker—women who have since been recognized for their unique insights into racism and the realities of African American experience.

Of all the literature I read in late adolescence, James Baldwin's *Nobody Knows My Name* probably had the greatest influence. The book was written, as Baldwin put it, "in various places and in many states of mind" during the 1950s. Baldwin was writing about his invisibility as a Negro writer who was just ending a six-year self-imposed exile in Europe. The book covered many topics and included a long eulogy for Richard Wright and an essay on Norman Mailer. But more than anything else, Baldwin wrote about racism, what he called "the question of color," and "graver questions of self." This

early introduction to writing as a way to explore identity along all of its vectors—ethnicity, gender, age, ability, sexuality, as well as cultural and social issues—was absolutely formative.

"It doesn't matter what you read," I once told a class of first-year college students. "It only matters that you make space and time to encounter the world through others' eyes and voices." Read newspapers and magazines, novels and poetry, essays and biographies, graphic novels and zines. Learn about the world through reading. Keep a reading journal like Marx did. This will greatly enhance your writing and your creativity in general.

There are many reading strategies. Browsing in a library or online is different from sustained reading of an author's work or repetitive reading of one particular text. I recommend that you experiment with each of these two strategies. This is precisely what I have done with two writers' work: feminist Mary Daly (1928–2010) and Tibetan Buddhist Patrul Rinpoche (1808–1887). I do not mean to compare these two writers here, for that would be impossible given the social and cultural frameworks in which each lived and from which they wrote. Daly was an outspoken critic of the social and cultural patterns that have led to our current global crises, while Patrul Rinpoche wrote one of the best-loved introductions to the path of dharma study. But focused and repetitive reading of each writer has had an enormous influence on me.

Few writers or artists have articulated such a vehement and sustained critique of contemporary culture as Mary Daly. Her professional life was spent as a professor in the theology department of Boston College, a Christian institution, where she was often embroiled in conflicts over values and politics. Daly's many books may be read as one continuously spiraling argument, articulating a prolonged plea for attention to the necrophilia or love of death that pervades our media culture. With Daly, I want to affirm biophilia, a vision of the interconnection of all living beings and the need to love all of life. Her writing demonstrates the revelatory and transformative power of language.

The title of Daly's book *Gyn/Ecology* exemplifies the way Daly created with language. *Gyn* means "woman." *Ecology* is the science that addresses the complex interdependence of living organisms and their environments. She punned on the fact that many gynecologists in our culture are male and that doctors, among others, can cause disease. "I am using the term . . . loosely, that is, freely," wrote Daly, "to describe the science, that is the process of know-ing, of 'loose' women who choose to be subjects and not

mere objects of enquiry."[1] Gyn/Ecology is, for her, the process of women discovering a web of loving relationships where everything is connected.

That Daly's language was simultaneously playful and didactic is most evident in her radical feminist alternative dictionary, *Websters' First New Intergalactic Wickedary of the English Language*. There she defines *snool* as "a cringing person" or "a tame, abject or mean-spirited person." Snools are the agents of the sadostate, that is, our society. Variously called bores, fakes, hacks, jerks, jocks, plug-uglies, rippers, sneaks, snookers, snot boys, and wantwits, these social types can "take over" individuals when they act in ways that help maintain patriarchy. Daly clearly understood how to use satire and humor as powerful literary devices. While her words may evoke laughter, behind their humor lies the conviction that unless changes happen now, our planet will become lifeless.

Daly's language could be brutal and lyrical, whimsical and acrimonious. Reading her work demands focused attention, yet it yields both humorous and jolting insights. For the reader willing to travel with her, the journey is arduous. Her work demonstrates that language is ultimately a vehicle for the transformation of consciousness. With the term *Be-ing*, for instance, Mary Daly emphasizes the importance of moving beyond anthropomorphic and reified concepts of God within a Christian framework. Her claim that "when God is male, the male is god" became a touchstone for my own evolving critique of Christian patriarchalism. Be-ing is meant to signify both ultimate and intimate reality—the idea that the divine and mundane always coexist.

In contrast, Patrul Rinpoche is not known as a cultural critic, but was a much-loved Tibetan Buddhist teacher. His *Words of My Perfect Teacher* is considered one of the most comprehensive manuals of practical advice for those who set out to study the dharma. For me, this book describes a powerful way of transforming one's mind and one's life. Although I already had considerable experience with meditation practice, I first read this book in 2006. I was beginning to learn more about the intricacies of the Vajrayana path from my teacher Dzigar Kongtrül Rinpoche and the Mangala Shri Bhuti sangha. Since then, I have read it many times, and each reading deepens my understanding of Buddhist practice.

1. Daly, *Gyn/Ecology*, 10.

FIGURE 2

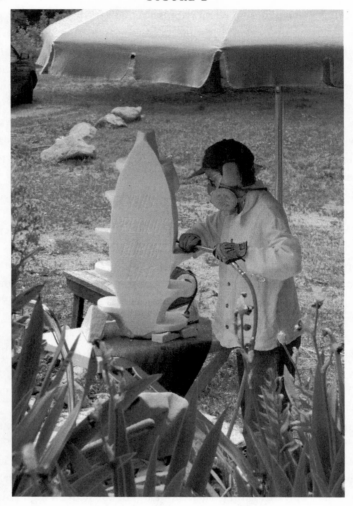

Patrul Rinpoche's text begins by starkly outlining the outer prelimi-
nary practices, known as the Four Thoughts That Turn the Mind toward the
Dharma, or the Four Reminders. Understanding their implications more
fully has been a constant spur on my spiritual path. The first reminder is
that we should contemplate the preciousness and advantages of a human
life, and as a result, we must strive to act in meaningful ways. This reminder
is often described as "this precious human life." Following the deaths of
six people in an eight-month period in 2005 to 2006, I worked for more
than four years on a marble memorial—a five-foot-tall standing stone.

FIGURE 3

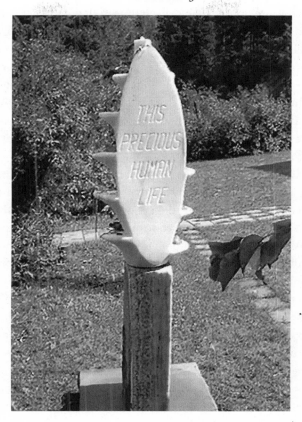

I wrestled with how to give form to the grief and loss I experienced following the deaths of my mother, one of my dearest friends, a student, a cousin, and two others. I carved the words "This Precious Human Life" on one of the stone faces, yet it never occurred to me that it could be impermanent. This stone monolith disappeared in the 2013 Colorado floods. Carried away by the raging river or buried, only part of its base has been found.

The second of Patrul Rinpoche's reminders concerns the impermanence of all phenomena. The outer universe in which we live is impermanent—including the seasons and days; the periods of famine, war, disease, and the other plagues that haunt us; and the cycles of growth and decline in forests and civilizations. The lives of all sentient beings, including family and friends, the wealthy and powerful, and holy men and women, are impermanent. The whole world is impermanent. In this context, death is certain, yet we must live with uncertainty about the circumstances of our

own and others' deaths. Both good fortune and poverty do not last forever. Joy and sorrow are unpredictable. Even time itself is ephemeral. Everything that is born must die. This awareness of impermanence and the inevitability of aging, illness, and death lead to suffering. There is pain itself, physical and emotional, and there is the suffering of suffering. Close to home, we lose our parents, siblings, dearest friends, and beloved animal companions. My husband continues his years-long process of cognitive decline. We watch the horrors of war, often from afar, yet suffer the consequences of these never-ending conflicts. Patrul Rinpoche strongly advises that we regularly contemplate such realities.

All this leads to the third reminder: in samsara we encounter suffering. From a Buddhist perspective, our negative emotions and the consequences of our speech, thought, and actions propel us from birth to rebirth in an endless cycle. We may be reborn in hell realms as hungry ghosts or animals. We may be reborn as humans and not only experience multiple forms of suffering, but also have the precious opportunity to work with our minds. We may be reborn as demigods or gods who enjoy an abundance of pleasures and comforts but who still experience the sufferings of death and rebirth. These are not just places, they are states of mind. In whatever state, samsara is a life full of addictions to things and to the five negative emotions. Patrul Rinpoche compares this circular process of a samsaric existence to the life of a fly trapped in a jar: wherever it flies, the fly cannot exit.

The fourth reminder describes how karma, the principle of cause and effect, is active in our lives whether we believe in it or not. Negative actions, such as killing, lying, stealing, sexual misconduct, and wishing harm on others must be avoided. We should also abandon what Patrul Rinpoche calls "wrong views," persistent harmful or misguided beliefs about ourselves, others, and the world. Instead, we should adopt positive actions, including practicing generosity and discipline, telling the truth and helping to mediate disputes, protecting and helping others, reciting prayers, and putting an end to wrong views. My teacher, Kongtrül Rinpoche, advises that Patrul Rinpoche's chapter on karma is a manual for how to live. Other chapters of this long book describe preliminary practices, including prostrations, mantras, and prayers.

For twenty months during which I was doing these preliminary practices daily, I worked on a large mixed media drawing titled *Practice Map*. Each day, I drew on this thirty-five-foot-long handscroll, using symbols to track each day's meditation practice, which included sitting, walking, and other contemplative forms described in Patrul Rinpoche's book *Words*

of My Perfect Teacher. Practice Map started out as a log, a record of daily practice that kept me accountable. But as a work of art, it has and will have its own life. When the scroll was first exhibited in early 2010, it was placed on a large table where viewers were invited to use gloves to roll it out so that new areas were visible.

FIGURE 4

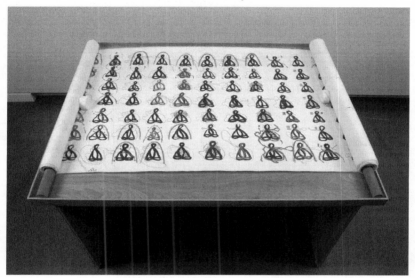

Practice Map flowed from and through the practice, and both art and practice were birthed as a result of my reading, in this case, *Words of My Perfect Teacher.* Reading inspired and shaped my life and my art. In turn, my art further inspired my life and understanding. This is the power of reading.

Is it possible to embrace and ultimately overcome the challenges and obstacles—the *maras*—that come to us in life? This is not an easy path, either in the external world or in one's own mind, because it requires openness and diligence. You need skillful means to learn to work with your spirit, mind, and body, and the outer and inner preliminaries described in *Words of My Perfect Teacher* have been just that for me. I find great value in reading this book repeatedly, as well as commentaries such as Dzongsar Jamyang Khyentse's book *Not for Happiness: A Guide to the So-Called Preliminary Practices.* I also find great value in giving form, though art, to my meditation practice.

If you are a Buddhist, I urge you to consider the role of study in relation to meditation and to seek out the written wisdom of your particular lineage and tradition. If you are not Buddhist, simply look for books that best speak to you. The insights of others will sustain you through the storms on this ocean of life.

5

The Fire of Adversity

➤ *Remember that everything changes, always.*

ONCE I DREAMED THAT three boys threw something into an old car that sat on a city street. A small flame began to burn. Carefully noting the boys' clothes so I could identify them, I ran after them, nearly catching one, but they got away. Then the car was engulfed in flames and I stood behind a wall, yelling, *"Fire! Fire!"* I sensed that an explosion was imminent. When next I peered out, I saw that the fire had destroyed everything.

This dream reminds me that when I was a young child, our neighbor's house caught fire one night. I stood transfixed as the firefighters turned the flames to smoke, and the house was saved. Fire consumes and destroys, and it is a primordial metaphor for all kinds of adversity. Yet I have seen—at Mount St. Helens in Washington State, in Yellowstone National Park in Wyoming, and on Mount Porphory in Jamestown, Colorado—that fire prepares the way for new growth. How might we understand the meaning and power of fire, and in particular how might reflection about fire help us deal with difficulty and adversity?

I first started thinking seriously about fire as a young college student. At the urging of my ceramics professor, I observed a candle, trying to comprehend the colors of heat. Simultaneously, I learned that this is an ancient method of training the mind for meditation. Wanting to understand the differences between conduction, convection, and radiation, I looked up the treatises of the English scientist Michael Faraday (1791–1867) concerning how energy is transformed. In the days before computerized kilns, I also

learned to dance with that magic flame. Like the mythological Greek god-dess Hestia, I tended the fire, adjusting the burners as the interior chamber temperature rose from dull orange to white heat. I made a series of vestal virgins. But my personal enchantment with fire is only a small part of this narrative.

In folklore, mythology, and religion, stories of the origins and power of fire are ubiquitous. The ancient Indo-Iranian fire god Agni was a wise emissary between the gods and humans. Zoroastrians worshipped and still worship fire as the unseen vital force that pervades all creation. Greek and Roman myths gave special place to female deities and actual women as keepers of the flame. Reverent Hindus wish to die in Varanasi and to be cre-mated in the ghats on the banks of the Ganges in order to escape rebirth. In Vajrayana Buddhism fire rituals or *lhasangs* are used to cleanse and purify. Jews and Christians associate fire with the holiness and ineffability of God, with divine judgment and the fires of hell. The yule log and the bonfires of midsummer solstice are but two of the enduring pagan rituals that unite family and community in Christian-based cultures.

One of the few attempts to create a phenomenology of fire was Gaston Bachelard's *Psychoanalysis of Fire*. What is fire? That is the question Bach-elard sought to answer. He studied both mythological and scientific expla-nations—what he called the subjective and objective interpretations of this element. Fire, he claimed, explains everything. Because it is both intimate and universal, Bachelard called fire the ultraliving element. As it lives in our hearts, so it lives in the sky. It rises from the depths of our being, and is expressed in love as well as hate. It is good and evil, gentleness and torture.

The imagination, like fire, is an autochthonous realm. The word *autochthonous* is derived from the Greek *autos*, "self," and *chthon*, "of the earth, land, or ground." Imagination is as intrinsic to our nature as heat is to flame. It inhabits us, as people inhabit the land. We need it, for only the imagination allows us to contemplate the future without forgetting the past. Imagination works at the summit of the mind like a flame. Who among us has not sat before a fire watching the colors of the flame, watching the logs (or the paper or dung) being consumed as we warm ourselves? And who among us has not drifted into a state of reverie, reflecting on the past and future as we watch the magic? The harnessing of fire was clearly one of the most formative human innovations.

Fire is a powerful transformative element. It teaches us about the in-exorability of change, in art as in life. M. C. Richards's musings about fire in

Centering in Pottery, Poetry, and the Person have been a touchstone for me. She wrote about the "innerness of the so-called outer world," the ways we can read the physical elements as metaphors for inner processes. The kiln becomes the crucible of hellfire, the fire of suffering, the flame from which the phoenix rises. Fire purifies, renews, and transforms. Out of fire, the new is born, and reborn again.

What do you do when faced with the fire of adversity? Do you fight it? Do you flee? What do you do when encountering obstacles, barriers, or blocks in what you thought was a straightforward process? How do you react when faced with a strenuous or formidable task? How do you manage when you come up against the limitations of your ability and knowledge? And what happens when your vision outstrips your ability or an accident irreversibly changes the direction of your life and work? These are all examples of the kinds of adversity you can expect to encounter in the creative process. The main question is, what to do?

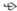

Once, when I was attending an eight-day marble-carving symposium, all of these obstacles seemed to appear simultaneously. For nearly a year I had imagined carving a full-sized chair on which I would carve a few words. The form of the chair was simple, my plan precise. When I arrived at the marble site, I could not find an appropriate block of marble. But then I remembered an earlier aspiration, to make a standing stone. Previously, all of my work had been on horizontal stones, where I treated the marble as a two-dimensional surface on which to write. I had no real notion of what I was getting into, but the idea of a standing stone, about my height, was so compelling that I innocently selected a beautiful block of marble with veins that looked like lightning.

Then the trouble began. I was not trained as a sculptor, not trained to think in three dimensions. I had never worked sculpturally in a subtractive medium such as stone. I had never faced the challenges of mass, volume, and transitional planes, as well as surface, texture, and language for a large piece. None of my previous work in ceramics, drawing, installation, or performance prepared me for this challenge. I endured one breakdown after another. The stone had blemishes that I could not remove. I wanted to leave. I couldn't figure out what to do next. I wanted to avoid the site

and drop the project. I wanted to flail my arms, stomp my feet, and cry in anguish. It all sounds silly in retrospect, but the experience was profound.

What did I do? I did not hit the stone or work on it aggressively because stone bruises, just like people. I took breaks. I put my feet in the creek. I came to work after dark or at dawn, when I could be alone. Later, I asked for technical and conceptual help. I made drawings. I modified my ambitions. I got a massage. I returned to the stone, again and again, when I felt calm and could look dispassionately at my progress. On the last day of the symposium, I wrote the words that I had planned for so long.

Through this process, I learned a lot about marble and about myself. I learned about scale and ambition, about the need to define a project carefully and not to set unrealistic expectations. I learned that I could address stone as a three-dimensional object in space. I learned that my keenest pleasure comes from the one-pointed attention that is required for writing in stone, as it is for meditation. More than anything else, I learned about the fire of adversity.

FIGURE 5

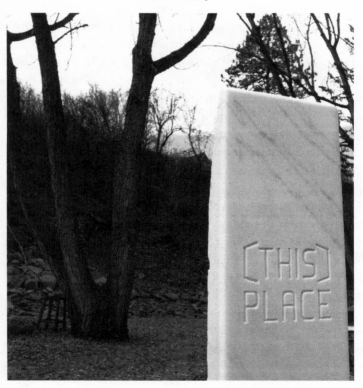

I could have fought the stone. I could have left the project. But I chose another path: staying with the frustration, taking another step forward when I knew that I could have turned back. I placed that standing stone in my garden, carved with the words [THIS] PLACE on its face. *This place*, being here, present, now, at this moment, to observe. Like the proverbial phoenix rising from the fire, I was transformed by the experience of working on this stone.

<p style="text-align:center">↭</p>

Adversity shows up in multitudinous forms and has unexpected consequences. You have the flu and cannot, or will not, stop to rest and care for yourself. Your dearest friend is diagnosed with advanced breast cancer, and you help to care for her through a difficult decline and death. Multiple family members and friends die in a short period of time, and you struggle with how to digest so much suffering. A massive, unexpected flood destroys the home you have created. Like fire, water destroys, cleanses, purifies, and transforms the world that we think of as real and solid.

In September 2013, my community in Jamestown, Colorado, was devastated by what was initially described dramatically as a thousand-year flood. A year's annual precipitation, about seventeen inches, fell in a few days. It changed the course of the James Creek, destroying the town infrastructure and scouring the site where my husband and I had lived and worked for fifteen years. Initially, we did not know the extent of loss in Jamestown. Before we were airlifted out of town, we sat on high ground above our place, watching as floodwaters battered the two remaining buildings on the site. Three other buildings had already been destroyed.

Photographs sent to me a few days later showed our house tilting to one side. But these photos proved deceptive. The house withstood the water, with damage that we were able to mitigate. The studio, which was half full of mud, was completely cleared out by an exceptional volunteer group of Texas Baptists. The crew was able to find a few items, such as family pewter and some unbroken china, but all of my stone, tools, and art stored in the studio had vanished downstream. The site itself, about which I wrote in *Book of This Place: The Land, Art & Spirituality*, was altered, as if some great hand had absconded with most of its former form, leaving only scattered bits and pieces. Of the many marble sculptures I had carved, fragments of several were excavated from debris, including [THIS] PLACE. Two others remained intact, though damaged.

FIGURE 6

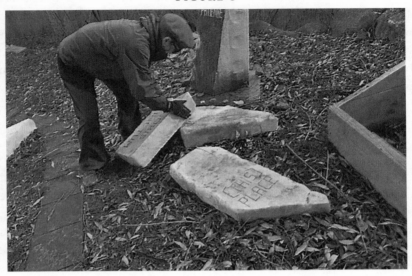

Innumerable logistics demanded attention over the years of recovery and rebuilding. Mostly, the practical necessities of daily life dominated the days. And then there was the deeper level. Some days were difficult, full of grief about the many layers of loss. It had been a long time since I'd felt this depth of primal pain. In the best moments, my personal loss gave me a new level of understanding and compassion for what others lost in this disaster affecting tens of thousands of people in Colorado, and for others' suffering elsewhere in the world—in Thailand, Japan, the Philippines, central Africa, and in places closer to home in the United States where fires and floods, hurricanes and tornados, snatched away people's lives. At other moments, I floated in a seemingly never-ending tide of sorrow. Perhaps this is akin to what Chögyam Trungpa Rinpoche called "the genuine heart of sadness" that lies at the root of human experience. I wound my way between heartbreak and logistics, between compassion and daily necessities. It was, and remains, a rocky path.

We lost the site, although the property remained. Contractors working for the county and state literally moved the creek from the center of our property back into its creek bed with huge excavators. Massive rock berms were constructed where the medicinal garden had been. The entire contemplative garden, with its marble carvings and many benches and chairs, was gone. Twenty-six trees, including ten fruit trees, as well as planted beds and a stone circumambulation path were gone. Most of the marble sculptures in

the contemplative garden were gone. A lifetime of art and stone tools had vanished downstream. I mourned these losses.

I mourned the loss of the vision of what my retirement would be: digging into the process of exploring my art, especially finding out what I am capable of as an artist in the last decades of my life. Having given so much energy to others as a professor, administrator, and public citizen for forty years, I looked forward to undertaking an inner journey that would be expressed through further developing the contemplative garden and carving new stones. I had gathered what I needed for this journey—for instance, a four-foot-tall marble block from Marble, Colorado, for a stupa and another exquisite, large marble slab from Carrara, Italy, on which I planned to engrave words from the famous *Prajnaparamita Sutras*. These and other stones were gone.

I mourned the loss of my ten-by-fourteen-foot meditation cabin, which I called the Stone Studio because of its earlier incarnation as the place where I stored all my carving tools. In particular, I mourned the loss of plans to conduct a three-month solitary retreat there during the winter of 2014. The cabin was simply prepared with five Buddhist thangkas, one of my own large drawings, and a painting by my teacher, Kongtrül Rinpoche. A maple table made by fine woodworker Tak Kida held my practice materials. The cabin also contained a shrine with the accouterments that support meditation practice, including a marble Buddha that I had refinished and polished to what carvers call a "snowflake" finish because of the way it shimmers in the light. All gone.

At Ivydell—one of the names I called our place in Jamestown—I aspired to plant more trees, expand the medicinal garden, create a roofless stone building around an outdoor sanctuary, and continue carving words in marble, developing the sculpture garden. I knew that such tasks would take years. But life unfolds in unexpected ways. Fires and floods destroy places and dreams.

Such was the shape of my grief. Have I remained in despair about such losses? No. Homo sapiens is a resilient species. We survived ice ages and painted in caves in France and on rock walls in north Africa. We built stone circles and placed standing stones in isolated places such as Orkney and the Outer Hebrides. Will I proceed on the inner journey I envisioned? No. But my path is unfolding in new, yet-to-be-determined directions.

6

Inner Work

> ➢ *Carefully observe the processes of living, dying, and rebirth as they*
> *occur in the immediate environment. This is a profound spiritual*
> *practice, and it will affect every aspect of your being.*

I GET UP THIS MORNING at 5:30 a.m. and brew a cup of Fukamushi, one of
my favorite Japanese green teas. Sitting in a low chair facing east, I sip the
tea, watching light come into the day. At first the sky is a deep midnight-
blue, then it gradually changes hue, now gray with faint rosy streaks to the
east. Bare tree branches filter colored light. Now, floating pillows of pink in-
termingle with baby blue. A train whistles nearby and the furnace rumbles;
distant sirens sound. We are in a city, albeit a small city, and cars speed by
as people head for work. In the house across the street, lights come on and
children prepare for school. Streaks of color become mauve, then begin to
fade to white. Between moments of verbal chatter, I sit quietly, observing
my breath. When the sun finally rises over the horizon, I close my eyes. This
all seems quite normal, yet it is my first lesson of the day in groundlessness.
Nothing is solid or stable.

You wouldn't imagine that I was reflecting about such matters if you
had followed me around right after the 2013 flood. I was submerged in
the logistics of daily life: gathering materials for my first-ever conversa-
tion with a financial advisor; preparing to meet with our accountant to talk
about the tax implications of the flood; clarifying what my benefits would
be after my retirement from university work; confirming flood insurance
details with our insurance agent; applying to FEMA for housing assistance

recertification; completing our loan application for the Small Business Administration; visiting the AT&T Store about a newly purchased tablet; working in my university office on a project that would soon be completed; making appointments to look at three potential assisted living and memory care facilities for my husband, David; considering longer-term housing in Longmont and Boulder, which meant looking at houses and condos with a real estate agent; and investigating flooring, garage doors, French doors, enclosed showers with a seat and handholds, spray foam insulation, and more for the repairs to our flood-damaged house. All of these details would seem to be a way of creating a new ground, and in a commonsense way, I suppose that is what I was doing.

But there was another way to look at this process related to the Buddhist *lojong*, a text by Chekawa Yeshe Dorje, which is based on the teachings of the tenth-century Indian master Atisha. *The Root Text of the Seven Points of Training the Mind* consists of seven key points that are subdivided into fifty-nine slogans. Norman Fischer, a Zen Buddhist priest and poet, published an accessible introduction to these slogans titled *Training in Compassion*. My teacher, Kongtrül Rinpoche, had taught on the *lojong* several times in the past few years and published *The Intelligent Heart* about them.

The very first slogan is "train in the preliminaries," which can be understood in many ways. From one perspective, I might begin by acknowledging that this is my life, and I am capable of dealing with whatever arises. I accept personal responsibility for what is. Or I might look honestly at my life, make a clear decision about how to continue on this disciplined Buddhist path, and reinvigorate my meditation practice, which will provide inspiration for my path. Or I might consider the Four Thoughts.

These Four Reminders, described earlier, have been an essential inspiration. Simply put, the first reminder is that life is precious and impermanent. Everything is subject to change. Second, death is inevitable. Third, all of our actions have consequences—karma exists. Therefore, it behooves us to contemplate the connections of our mental states and actions by looking at the causes and effects of our thinking, speaking, and acting. And fourth, suffering is inevitable. The life of samsara is unsatisfactory.

For me, to train in the preliminaries meant to accept that my old life had come to an end. My vision and aspirations about what life would be— that month, the following winter, and in the next few years—evaporated. I needed to take time to review my life and goals, especially in face of the fact that nothing is certain. Spring runoff in the mountains could cause another

massive flood, destroying what we were trying to rebuild in Jamestown. Fire is always an imminent danger in the surrounding forests. In recent years, there had been three fires in our canyon alone and other destructive fires in Colorado. Did that reality keep us from repairing and rebuilding what was destroyed? No, of course not. But it gave me pause.

Every day offered another lesson in contingency. Contingency is not the same as groundlessness, but they are related. Because everything is contingent, constantly in flux, there is no solid ground on which to stand. This, for me, is both a literal and figurative reality. One day early in the postflood recovery effort, I was in Jamestown. Sitting on that cool morning among nine tall willows that I had dubbed the Sisters, I listened to the wind and rushing water and watched a pair of purple finches. I knew that these trees would be removed shortly by massive excavators and front-end loaders to provide space for the "armoring" of the creek—the placement of multiple layers of stone that would hopefully survive the next flood.

How often in time past I had lain there on cool marble, listening to the world. How often I had lain on the *Lovingkindness* stone gazing up at the willow branches and sky above, the prayer pressing into my back. How often I had sat among these Sisters, finding solace in the quietude of nature. How utterly changed it was. That stone was found in four fragments, which I placed together again in my Longmont garden. How utterly changed I was. What did I know then, and what do I know now?

FIGURE 7

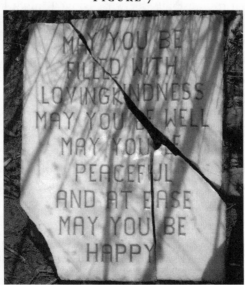

34

I knew the vicissitudes of grief. I understood in my gut how deep grief can linger when there are compounded losses. I didn't care about the house, nearly repaired at that point. *Let me say it again.* I had lost all of my stone tools, marble sculptures, and uncarved marble, plus most of my historical art. I had lost the meditation cabin, and everything in it—sacred objects, thangkas, and more. I had lost the circumambulation path, the garden, the perches—those seats I had constructed over years for pausing on my daily meditative walk. I had lost the community that supported David after the onset of his dementia. I had lost the possibility of carrying out the post-retirement vision of a contemplative and creative life, developed over years. The land itself was gone, denuded. I wondered then as I wonder now, where is home? I do not know where I belong.

I knew the angle of repose, how earth fell down into the massive hole dug for our new septic field, a complicated and expensive system. Building the rock wall that would stabilize the raised structure redefined the meaning of earthwork for me. Without that wall, the angle of repose could erode the entire construction. The creek, should it flood again, might easily do the same.

I knew faith: faith that aging, illness, and death are natural; faith in the process of healing; faith in my resilience; and faith in the path that I walked. And I certainly knew the truth of impermanence. As that wise old gestaltist Barry Stevens put it, "You can't step into the same river twice."

That knowledge of the vicissitudes of grief, the angle of repose, and faith remain with me. I have long known the phrase *negative capability*, and it is a powerful way to reflect about what continues to be required of me. The phrase was coined by the young poet John Keats, in a December 1817 letter to his brothers George and Thomas. Keats, a great admirer of Shakespeare, wrote, "At once it struck me, what quality went to form a Man of Achievement, especially in literature, and which Shakespeare possessed so enormously—I mean Negative Capability, that is when man is capable of being in uncertainties, mysteries, doubts, without any irritable reaching after fact and reason."[2] Negative capability means to be able to live amid uncertainty, mystery, and doubt. In my own language, it means to face the impermanence of all phenomena without grasping for something solid. And that is a challenge without parallel, a challenge I accepted every time I entered the one-acre site. The flood transformed the land and place into something I could never have anticipated but have accepted.

2. In "On Negative Capability," *Letters of John Keats*, 1:193–94.

So many changes were wrought on the land, and aspects of our place remain unrecognizable. On the western end of the property, the land itself is gone, replaced by massive rocks that, hopefully, will protect the area from further flooding. I have scrambled over them, down to the widened creek and back up again. I no longer think of stone as permanent or immovable or unsusceptible to change. This awareness is part of my practice of negative capability. But their sturdy presence is calming, nonetheless. Those multiton stones inspire me in an inchoate way. I begin to feel the desire to work with stone once again.

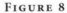

FIGURE 8

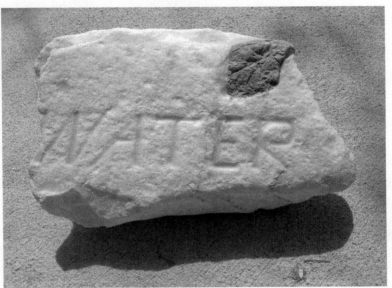

This desire was amplified when one of the large front-end loader operators found a fragment of my *Water* stone in the sandy creek bed where he was dredging, downstream from our place. The stone, which originally weighed about fifty pounds, is now about half its size, but the word is intact. I wondered whether to put it into the creek again, where it would function as a reminder to me that we live in a dry mountain environment where drought is always a possibility. Now the resonance is more about the unpredictability of this magical element.

Sometimes, as I am describing here, change is so unexpected that it takes your breath away. Life is turned upside down, with all expectations and visions of the present and future swept away in a massive flash flood.

Everything you have spent years creating is suddenly gone, and this causes suffering. But there are other, less emotionally charged images to describe this temporary quality of experience and of human existence.

It is like writing on moving water with your fingers. How quickly the stream flows on, obliterating precious thoughts. Or it is like a candle flickering in a doorway, where the slightest wind snuffs out the light. Or it is like clouds in autumn, or a flash of lightning on the distant plain. Or it is like a mirage of water ahead on the roadway that disappears the closer you get to it. But none of these is quite as spectacular as a massive double rainbow stretching across the plains, where it caresses the ground from south to north. And during periods of tumultuous weather in central Colorado, rainbows sometimes appear out of nowhere—breathtakingly beautiful. But more striking than the appearance of this profound beauty is its disappearance. One moment, the earth and sky seem alive; the next moment, it's gone to gray. Like that rainbow, absolutely nothing has intrinsic permanent existence.

The rainbow is my symbol for the fragility and impermanence of all phenomena.

7

Ritual

➤ *We make and remake our world through ritual.*

➤ *Although you may be unaware of their presence in your life, both personal and collective rituals affect every aspect of your thought and action.*

BECAUSE I WAS RAISED within a secular family, I had no experience of religious ritual as a significant category in human experience. I locate the origins of my curiosity about ritual in the arts, first in the experience of learning to play the flute in my youth—daily practice, playing in bands and orchestras throughout my teen years—and then turning to the visual arts, especially ceramics. I learned to throw pots through repetition, systematically explored glaze chemistry through trial after trial of making my own glaze recipes, and then became adept at firing kilns through sustained practice. Later, after I had begun to teach ceramics and coordinated building a large kiln at a community college, I made my first formal installations and performances, all of which involved ritual processes.

My engagement with ritual has been both intellectual and somatic. For instance, in 1990 I constructed a comprehensive bibliography on theories of ritual and gathered dozens of articles for a prospective book about ritual. Considered generally, ritual plays determinative roles in religion; in secular ceremonies; in politics as rites of rebellion, solidarity, or both; in games and organized sports; in personal habits of grooming and dress; and in all of the arts. Both personally and communally, we create rituals for

everyday life, for significant transitions such as birth, puberty, marriage, and death, for holidays and family celebrations, and especially for dealing with grief and loss. In short, ritual is a universal category that describes key aspects of social life. In the extensive literature on ritual and myth, ritual is often differentiated from ceremony, magic, and social etiquette, but here I am using the category in its most general terms.

FIGURE 9

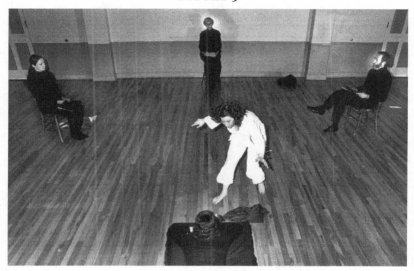

Ritual begins with the body, where breath and breathing are thresholds between the body and mind. Most rituals include at least six elements. Such an outline is not meant to be inclusive of all ritual forms, but it is a framework for beginning to think about how and why we humans engage in ritual activity. As an example of how these elements of a ritual might develop in a work of art, I describe them in relation to *FAER/fear*, an hour-long performance that I created and performed in 1982. The topic of this ritual performance was fears that had been formative in my life. Buddhists describe the eight worldly concerns in many ways, but all are linked to hope and fear: hope for happiness, fame, praise, and gain; and fear of suffering and loss, insignificance and blame. I worked directly with all these fears in that ritual performance. I had first understood the destructive nature of fear in a therapeutic setting. Later, especially when reading and listening to Pema Chödrön's extensive teachings on fear and fearlessness, I knew that my work of preparing for and conducting this ritual performance had been efficacious.

First, rituals have their own language, words, postures, movement, and gestures that act as what anthropologist Victor Turner called "processional units." *FAER* included a narrative in several voices, as well as choreographed movement and sound. This ritual language quite literally described how I was to proceed in the performance.

Second, rituals involve symbolic action. What I did in *FAER*, especially my movement and gestures, was not a means to an ordinary end, but symbolized other levels of experience. When I crouched or lay on my belly, for example, I reenacted difficult experiences that had led to significant obstacles.

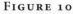

FIGURE 10

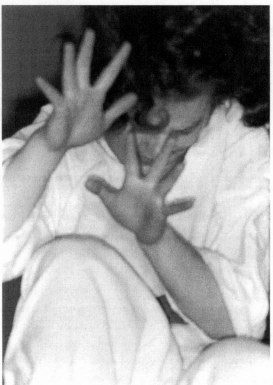

Third, ritual is repetitive. Action is carried out again and again, sometimes altered, but essentially consistent. Perhaps personal and cultural difficulties with ritual have to do with our fascination with the novel and a subtle or explicit rejection of the familiar. I do not mind repetition. In fact,

I found great freedom in and through my repetition of particular sounds in performing *FAER*. Like Buddhist mantras, sounding helped to focus my attention.

The fourth and fifth points are related. Fourth, ritual is formal. Whatever the form, it must be capable of bearing both the content and context out of which it grows. Fifth, rituals may be communal or solitary. Community is shaped by ritual and the traditions of that particular community. Theorists such as Catherine Bell have focused on these two characteristics of ritual as the most determinative. Bell suggests that ritual fosters group enthusiasm and repetition of traditional norms and activities. Through rituals we engage the body using movement and stillness, sound and silence. Rituals can function as a form of social control and as a form of exemplary religious behavior, yet they can also tolerate the internal resistance of participants. We may reject religion and spirituality as a way of rejecting rituals of control, but what if we have more freedom in our ritual practice than we think?

To create rituals—which I have done in my role as a performance artist—is one thing, but when and how is it possible to exercise independence within forms stipulated by a tradition? When should you trust your own sense of how to proceed with a prescribed ritual? Like many dimensions of the artist's vocation, this requires considerable self-reflection. Intermittently this is an active question for me in relation to meditation practice, and I exercise caution when my ego wants to reject a particular ritual form or content. The question of when to practice strict adherence to ritual procedures and when to adapt them is best discussed with members of your community or your teacher.

Because *FAER/fear* was a ritual performance staged only once before an audience, it did not engage these last two general characteristics of ritual. However, unlike *Requiem for a Wasted Life*, which I performed alone as an elegy for my mother, I did involve others in *FAER/fear*. Poet Norman Weinstein helped me create the text and soundtrack, and three dear friends read the text aloud. Their involvement in the performance and the presence of a witnessing audience were part of the power of this ritual.

Ritual is transformative, and this is the sixth point. Through working within a framework of ritual time and space, I experienced significant change. Ritual time is outside of the usual activities of one's mundane life, yet it has an impact on the felt sense of daily experience. The space of ritual is often, though not necessarily, associated with the temple or stupa, church

or cathedral, and the thresholds of such spaces often have guardians. My friends acted as guardians of the space I created to enact *FAER*. In the time and space of *FAER*, my relationship to long-held fears was transformed. Simply put, both my attachment and aversion to these fears decreased. This is not to suggest that I never experience appropriate fear—as when faced with an imminent forest fire or flash flood, or when I help a dying friend in her last days. But such events, while life-changing, do not trigger my oldest fears of abandonment, physical abuse, or even death itself.

We might say that all spirituality is grounded in narratives and stories, myths of origin, and statements of belief about the visible and invisible worlds. Myths have many functions, but in the most general sense they serve as a set of beliefs or ideology that helps structure and explain personal and collective experience. Rituals enact myths, and myths and rituals together serve to harmonize the mind with the body and the body with the world. Writers such as Mircea Eliade and Joseph Campbell defined and chronicled myths and rituals from around the world. Buddhist rituals, with which I am most familiar, include both individual and group practices: prayer, mantra, and repetition of liturgies; bimonthly and biyearly feasts; and individual meditation practices.

A basic theme of all mythologies is that there is an invisible plane. Christians, Jews, and Muslims call this heaven or the afterlife. Buddhists refer to the sacred world. The concept of sacred world is complex. In its most basic sense, the term contrasts with everyday reality. We enter into the sacred world when we begin to question the solidity and permanence of conventional reality, when we participate in rituals and formal meditation practices, and when we create conditions of heightened awareness and wakefulness. For me, these moments of pure perception can also happen in daily life when I am totally free of self-concern, such as when I experience the sheer beauty of the world or perceive others' suffering with deep compassion.

Using this framework and way of understanding the interdependence of myths and rituals, Joseph Campbell has suggested that the artist's function is to remythologize the world and to reveal the great mysteries, however they are conceived. While this may seem grandiose, for me, this especially involves reflection about suffering, impermanence, dying, and death on both personal and global levels. Making art can help to create ritual space, and art can be created in a ritual fashion. Created in relation to ritual, art takes us out of profane time and into sacred time and sacred world, which was my experience as I performed *FAER/fear*.

~⊖~

There are many ways to use rituals in your daily life and in studio work, and here are a few examples from my own life and work. Multiple times each day I engage in "doorway" practice, which I learned from Olivia Hoblitzelle.[3] When I enter the room where my elderly husband is sleeping, I imagine in that moment that he may have died in his sleep. As I turn the door handle, I remember that while death is certain, I do not know the time or place of his death. Nor do I know the time or place of my own death, which may be sudden or prolonged. Doorway practice is a skillful means for facing the inevitability and uncertainty of death.

Nearly all cultures have a form of greeting, from formal waist bows in China and Japan to the familiar *namaste* greeting in India and various styles of handshakes, hugs, and kisses in many parts of the world. Over nearly ten years, I opened and closed both large and small university classes with a formal bow. Over more than eight years in smaller classes, I regularly taught techniques of mindfulness meditation as an aid to learning and building community in a class. The bow was one of the most successful of those techniques. Repeatedly, students told me that this was one of the most significant practices we would do together. I later experimented with teaching the bow to large lecture classes of 350–400 students. I would begin by explaining what the bow means. When we bow at the beginning of a class, we are saying, first, "I have arrived. No matter what else I was doing, I am here now." Second, we are saying, "I am here with respect, for myself, for all the others present in the room, and for the material that we will study today."

How does one bow? If sitting, sit up straight, place your hands on your knees and both feet on the floor, and soften your gaze toward the floor in front of you. Simply bow your head for a moment and sit up again. If you are standing, you might bend from the waist. In daily life, I bow as I enter my shrine room. I bow when I meet members of my sangha and when I meet a Buddhist teacher. I bow to the carpenter who built my studio and meditation cabin. I bow to the altar on the east wall as I enter that space.

When I enter the studio, I open the shrine. I light candles and incense. I say a prayer of aspiration and then bless the altar and the larger space. When I leave the studio for the day, I dedicate the merit of this auspicious activity with a simple Buddhist prayer that is attributed to Nagarjuna, who lived and worked in the second century CE: "By this merit may all obtain

3. Hoblitzelle, *Ten Thousand Joys*, 241.

omniscience, / May it defeat the enemy, wrongdoing. / From the stormy waves of birth, old age, sickness, and death, / From the ocean of samsara, may I free all beings."

These are merely examples of rituals I use in my own life. Become conscious of the personal rituals that already shape your work and your life, and consider what rituals might support your creativity in the studio. How do you enter the studio? Might you create an altar in your studio? Do you already have an area in your studio that serves as an altar, even though you may not have viewed it as such before now? What do you do when ending a work session? And are there ritual dimensions in the art itself? If the study of ritual engages you, you might read classic texts in anthropology by Arnold van Gennep, Victor Turner, Mary Douglas, and Clifford Geertz; in the study of religion by Mircea Eliade, Theodore Jennings, and Catherine Bell; and in folklore and mythology by Joseph Campbell and Edith Hamilton. Such investigation will inform your creative and meditation practices in surprising ways.

Why is ritual significant? You must answer that question for yourself. For me, the answer is simple: Ritual is an essential dimension of several aspects of my life. It is one of the ways I make and remake my life, one of the ways I give my life a sense of sacred structure in the present moment, and one of the ways I acknowledge the fundamental sacredness of life. My solitary daily meditation practice, as well as weekly, bimonthly, and biyearly communal practices with my sangha are rituals of stillness involving prayer and meditation and rituals of recitation and repetitive activity. Doorway practice and bowing are rituals that engage others.

My studio art now involves rituals of time and sacred space, and I now turn to a specific example—a performance I created in 2015.

8

Closing This Place: A Ritual in Parts

➢ *Rituals ground us in the present moment, while simultaneously*
signifying change.

Two years after massive floods that devastated Colorado's Front Range
in 2013, I conducted a ritual over several weeks in September. As I described
earlier, the floods destroyed the infrastructure of Jamestown, Colorado,
destroyed homes, and changed the face of the site where my husband and
I had lived for fifteen years. We worked for several years after the flood on
restoration. My ritual was both a celebration of our creative processes and
an act of letting go.

I had called our site by various names: 51 Main, Ivydell, and This
Place. But by whatever name, the site meant a great deal to us. Quite simply,
I needed to let go of the place and my time there, but I also needed a way
to acknowledge all that had been given to me by the site and what I left
behind. The ritual described here was a closing, a solitary performance to
acknowledge an ending. I have written about it in the present tense, both
as a way of staying true to my description of it at the time and as a way to
maintain the quality of present-moment activity inherent in the process.

⭐

I bring the ritual paraphernalia that I have prepared in my Longmont
studio to Jamestown today: texts, wands, drawings, maps, candles, incense,

marble, and more. I spread it out in my old studio upstairs in the now fully renovated house. After cleaning the kitchen, I go outside to walk what remains of the circumambulation path. I rake the path lightly and water the cover crop we have planted and replanted between the house and studio. After scrabbling down to the creek over massive granite boulders, I wash my hands, eat chocolate nibs, drink coconut café, and sip a little nettle-infused vodka. Crows circle, dip, and dive. I am quiet when I leave for the day.

<p style="text-align:center">⊕</p>

Mingling ritual activity with daily life, I arrive back in Jamestown and continue to clean the house and gather the few possessions that have remained there since the flood. A phone technician arrives, and I help him change over the phone for the renters who are moving in. I clean up the shards of a lightbulb that fell from the ceiling in my studio upstairs. Finally, after eating breakfast at the kitchen bar where we had eaten so many meals over the years, I begin the formal ritual.

Opening the shrine in my room with a candle and incense, I do twenty-one prostrations. Outside, I begin circumambulating with incense, blessing the site. I build stone cairns at four corners of the one-acre property. Honoring the spirits of the place, especially all the sentient beings that inhabit the foothills, I place chocolate, vodka, cookies, and apples at these corners and at two places where I recently found snakeskins.

I have brought three wands, sacred objects that I made in my studio. Created out of the detritus of the flood and covered with my recent drawings, the longest is nearly six feet and reminds me of the staff of Moses. Though it does not turn into a snake, a snakeskin that I had found is attached to the curvy willow root. I circumambulate with each of the three wands, the longest willow root first, then the yellow dock root, so difficult to dig out of the earth, then the foot-long marble core that is only one-inch in diameter. I continue to feel strangely quiet. I have no strong affect as I tread the path and stop to sit at the four cardinal points. Simply observing, I repeat aloud my appreciation. "How much you [this site] have given me."

Recently planted trees—Colorado spruce, wavy oak, serviceberry, and Kentucky coffee—need water. With hoses and buckets, I move around to each tree, blessing and consecrating the site, again and again.

FIGURE 11

In the studio, I spend a long time creating a living altar, a reliquary of sorts. This portable altar, which I put into a large glass vase, includes elements I found at Ivydell and some objects I made: sand, wood, and rocks from the site; flood debris, such as plastic and metal fragments; a necklace of old ivory dice to remind me of the power of fate and destiny; a tiny cup with a butterfly decal to hold a flower and slender stalks of lavender from the new garden; a small wooden human effigy, armless; a large blue marble; a quartz crystal that I found on a nearby hillside; feathers; and snakeskin. Rain has come and gone. The sun returns and the tree leaves glisten.

☙

The morning ride to Jamestown is exquisitely beautiful: maroon foothills; multiple shades of mauve in the cloudy skies; the big, yellow-orange rising sun. And when I arrive at 51 Main, two sparkles of sunlight glint on Mount Porphyry. My first activity inside the house includes removing the small portable altar from upstairs and setting it up in the kitchen. I light incense and a candle and then place new offerings beside the older bowl of offerings. A hand-sized stone carved with the mantra of the great Bodhisattva Avalokiteshvara rests beside these offerings. The living altar that I had finished a few days ago is surrounded by wildflowers.

A friend arrives and works for several hours to help me clean the house. While she is inside, I also work outside, loading a few big rocks into the car, digging up the one remaining spruce tree, and getting help to fix the old wheelbarrow that was damaged in the flood. I move hoses and stone pavers and do a bit of weeding. The house is clean and now ready for occupancy. The site is as tidy as it will be, mowed, weeded, and reseeded. Two friends stop by and talk for a while. One says that real estate is a good investment and that I should not sell. The other acknowledges how hard it is to be a landlord. He comments that he has seen people leave and never be able to afford to come back. Preferring solitude, I actively avoid visiting with others when they walk by.

Finally, after a bit of breakfast, I sit beside the window in the dining room and recite aloud the text that I wrote on a 22" x 30" drawing, *Closing [This] Place*, and then I record the text using my phone. Down at the creek, I submerge the drawing, weighting down the two ends with large stones. Immediately, paint on the front and back dissolves, and then, when I look again, the red urn and gold site map have washed away. This is so poignant and perfect. I use a handmade cedar basket to lift water from the creek in order to wash the drawing. Stepping into the creek, I fill a jar with water to take back to Longmont with me. I leave the drawing in the water and return to clear our remaining possessions from the house.

After loading everything I am taking with me into bins and bags, I return to the creek, where the drawing is still submerged. Pulling it out of the creek, I squat beside the rocks and slowly tear it, first into long strips and then into smaller sections that will fit inside the folded white mandorla. I gently use the linen thread that outlined this form to tie the small pile of pieces into a 4" x 5" bundle. I recite a dedication prayer several times. Created without forethought or plan, I ask myself, what is this odd artifact?

FIGURE 12

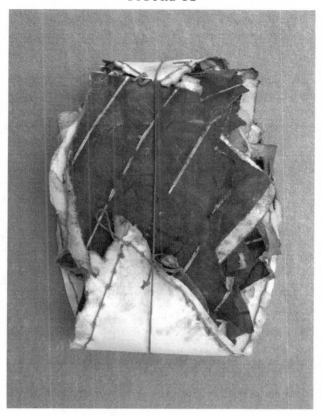

My grandson Camron arrives in the early afternoon while I am work-ing on the living altar in the kitchen, and we go outside. While he uses a string trimmer around the renovated house and studio, I scatter more cover crop seeds. Then, while he cuts the new grass in front of the house, I dig up and pot lavender plants, eat a few raspberries from the new raspberry plants, and dig out the one remaining spruce tree to bring to Longmont. Cam speaks about his memories and especially about what he did at our site in Jamestown while growing up. When he says that he feels sad to see the place go to others, I admit that I have grieved a lot but am now ready to let go.

The new renters arrive to begin unloading their van and review the many notes I have made for them. Then Cam and I pack the remainder of our boxes in the car, and I leave. Back in Longmont, I unpack the car and spend some time in the studio setting up the ritual artifacts and living altar

in a corner. Having spent so much time during these days reflecting and writing about my experiences, I feel deeply quiet. I have no further words.

<center>⟁</center>

A few days later, I begin to think about next jobs, especially typing up my ritual notes and creating a written narrative about the performance. As in the thirty-day ritual I created and performed for my mother, *Requiem for a Wasted Life*, and its text *Diary of a Requiem*, this will become a narrative of the structure and meaning of my performance. There is much to consider about the outer, inner, and innermost aspects of this ritual. The outer aspects include ritual activities and structure, the artifacts, and the question of why I wanted to create a ritual to mark this transition. The inner aspects of the ritual include my feelings and deeper reflections about the meaning of the ritual itself, as well as the nature of artifacts, such as wands and reliquary. The innermost or secret dimensions of the ritual cannot really be named and articulated.

<center>⟁</center>

I leave behind a vision of the future.

- I leave behind a place where I was creating a contemplative sculpture garden and where I could undertake sustained meditation retreats.

- I leave behind a site built with David, though by 2013, he no longer had the strength or stamina to help with the care of the site. But there, he could have aged in place.

- I leave behind a site that gave me deep solace.

- I leave behind a place where I learned about nature. There I observed the seasons, watched ice grow on rocks in the James Creek, documented the sun's arc across the cerulean sky, observed the play of clouds at seven thousand feet, and swam in the Milky Way at night.

- I leave behind a massive garden with paths and over fifty-three varieties of medicinal plants, fruit trees, and flowers, and marble perches from which to observe and experience the world.

- I leave behind a place with a stone yard where I carved marble and a site where I placed the sculptures inscribed with words.

- I leave behind the place where I conducted rituals, including daily circumambulation on the paths, as well as the thirty-day ritual for my mother. The stone I carved for her, which I buried to the west of the Sisters outdoor sanctuary, was swept away during the flood, along with the sanctuary itself.

- I leave behind many dreams and fantasies of what my old age would be.

- I leave behind proximity to many friends.

- I leave behind a place that is too big for me to take care of alone.

- I leave behind my own and David's fears of fire and flood.

Yet, I take so much with me.

- I am taking deep knowledge of the truth that everything is impermanent. Even stone is subject to the reality of impermanence.

- I am taking the capacity to hold experiences of suffering and to feel greater compassion for others who have lost or will lose as much as or more than I have lost.

- I am taking the experience of being part of a mountain community.

- I am taking a sense of home, of what home means and knowledge about what it takes to create a home.

- I am taking feelings of connection to the land and to a particular place.

I have given so much to the site and the community, and I have gotten so much back. I gave my heart, my body, my mind. I had imagined being there until death. Now I seek to release my holding on to all I experienced and imagined. Now I seek to release my attachment to all of it: the site, the land, living beside the James, the past, and the future.

- I release my holding on to the place and all of my dreams and visions.

- I release my attachment to what was, and to all of the prospects for what could be.

- I release my attachment to the house, to my studio, and to the new meditation cabin where I planned to begin a hundred-day meditation retreat in 2014.

- I release my attachment to all the "stuff" that was there: my historical art that was lost in the studio and the cherished art of others, correspondence with many of the dear ones of my life, and the tools and supplies of my artist trade that were acquired over decades.

- I release my attachment to the stones I spent years carving, especially to *Practice Chair, SIT, Altar, Mindfulness,* and to the massive Carrara marble slabs and Colorado yule marble block that awaited as next projects in my stone yard. I had planned to carve a stupa from one set of stones and a large slab with a prayer from the Buddhist *Prajnaparamita* or *Heart Sutra*: "*Om Gaté Gaté, Paragaté, Parasamgaté, Bodhi Svaha.*" (Gone, gone, gone to the other shore.)

- I release my attachment to what was and what is gone. I say these words and feel the losses.

- I release this place with heartfelt appreciation—gratitude singed by grief.

- I release this past.

- I release this past.

- I release all of what was, in order to open to what may be in the present moment.

- I release you, I release you. ("Said twice means I mean it," as my mother used to say.)

This period of my life with its visions, dreams, and fantasies has come to an end. This ritual is practice for dying. Admittedly, it is a small death, yet it is practice for death at the end of my life in this body and mind, in this place, in all places that I have known, and with all those I have loved. How could it be anything other than this?

✎

In retrospect, this ritual did what I had intended: It helped me to let go of my visions of what our place could be and of how the future might unfold. It effectively brought a sense of closure and simultaneously allowed me to express my love for the place and the community. The ritual helped me mourn what was gone and accept the conditions that had evolved. Back in my new studio, I kept the artifacts I had created and brought back in a

corner for many months, until I felt ready to put them away. Like my grief, the water from the James Creek evaporated over time.[4]

If this process of creating a ritual resonates with you, consider the places and spaces that you have loved, including sites where you have lived or presently live. What do they have to say to you?

4. The inspiration for this ritual arose during a studio consultation with artist Cynthia Moku. Many individuals contributed to reclamation of the buildings and the site. Especially I thank Andrew Shakespeare, who initiated the flood mitigation; Quinter Fike, who served as our primary contractor and did much of the work himself; Texas Baptist volunteers; and especially the many Mennonite volunteers who lived in the house for three months while working in Jamestown. A cadre of paid and unpaid workers helped me to reconstruct the house and studio and restore the site. My grandson Camron Pearce worked assiduously during the summer and early fall of 2015 on reclaiming the land. Together we moved tons of stone with Quinter's help in the backhoe, unloaded and spread truckloads of compost and mulch, planted grass and cover crop, placed large erosion cloths, mowed and weedwacked, and more. David had faith: he remained in the background, urging me to carry forward using my best judgment.

9

Sacred Space

➢ *All people, in all times, have created sacred space. Now it is time to treat the earth itself as sacred. Making art can be a vehicle for you to explore this.*

➢ *Observe with awe the ineffable beauty and mystery of the world. It is your responsibility as an artist to translate this experience and communicate it to others.*

WHY ARE WE HUMANS drawn to create rituals and sacred spaces? This is a big question, and it is one that I will try to answer personally. I have been creating such spaces for nearly forty years in galleries and where I live. And I have experienced the sacredness of space in places I have visited.

I have consistently felt compelled to work in ways that minimally impact the earth and our precious resources. In the late 1970s and 1980s, I created a series of installations and performances that dealt with themes of initiation, death, environmental destruction, and regeneration—all aspects of both inner and outer life. At the core of my concern was the desire to create sacred space. The word *sacred* is derived from the Middle English *sacren,* "to consecrate," and from the Latin *sacer,* "sacred." It names that which is worthy of human veneration, yet it is ultimately beyond our comprehension. Sacred space (a sanctuary or temple) is often opposed to profane space (a home or market). Rudolf Otto called it the *mysterium*

tremendum, the numinous, awe-inspiring, and wholly other mystery in which we live . . . and die.

The research, writing, and planning for these installations and performances began with two simple questions. First, what matters enough to warrant sustained attention and public presentation? Second, how is it possible to create using found or recycled materials and the intrinsic qualities of gesture, movement, and sound? As these questions found answers, two paths converged in my creative process: an ideological commitment to avoid the traps associated with producing art to meet consumer demands and the simultaneous pleasure of learning through years of meditation that the human body and voice are perhaps the most direct means for creative expression.

FIGURE 13

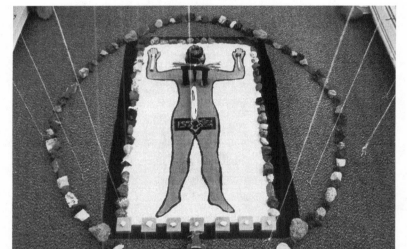

In the 1979 *Gaea* installation, for example, I expressed concern about the extinction of species, depletion of natural resources, pollution of the environment, and overpopulation of the planet. In preparing to install the piece, I drove across the state of Oregon, collecting stones, earth, sand, and sticks from various sites. Then I spent several days arranging these materials in a gallery to form a figure on the floor. After completing the installation itself, I posted a word-tree image on the wall.

The earth is precious,
a sacrosanct body on which we live.
She is a goddess, and this work is named
after the Greek goddess Gaea, who is the sure
foundation of all that is, the first being born of chaos
and from whom all else evolved. Here Gaea is composed
of naturally occurring materials, collected from my regional
environment, and replaceable there. This *prima materia* is
transformed by arranging rather than by unalterable firing.
Increasingly I choose to work in ways that sidestep habitual
cycles of production and consumption, that resist the commodity
market, that neither pollute nor use nonrenewable resources,
that loosen the boundaries and constrictions of Mind,
and that express an attitude of reverence for the
earth and coexistence with all sentient beings.

Still, my grasping mind asks,
but what is art?
My spirit gives an elusive ephemeral answer:

This body is a vision.
I am the earth as the sea is my blood.
I am clay,
sand,
stone,
stick,
string,
cinder,
and seed.

In two later installations titled *Temenos I* and *Temenos II*, I created spaces for contemplation using mostly found materials, as I had in *Gaea*—sand, stones, sticks, clay, and cloth. The Greek word *temenos* means "sacred precinct," a share of land apportioned to a deity and therefore a center for contemplation. Many cultures have defined sacred space using enclosures, structures, and gardens. In these gallery installations, I wanted to evoke the presence of a temple where the world might be resanctified. Although the two installations differed in structure and size, each included wall

56

paintings, figures constructed of earth materials on the floor, and texts on the walls. Each piece was related to my distress about the destruction of life on the planet. With a strong sense of urgency, I sought to reestablish a sense of connection with the body and with the earth, to rediscover the holy in all spaces and living beings.

In retrospect, I view these installations as courageous but partial. There are, of course, limitations to such gallery work. While they might provoke reflection, such installations do not actually create change in a place. Yet, these attempts to create sacred space helped me witness the sacredness of place.

<center>⊷</center>

Travel to an ancient site had a profound impact on my evolving understanding of sacred space. On the northern Aegean island of Samothraki, Greece, I experienced the magic, mystery, and sacredness of place in two ways. While difficult to separate, the first was related to ancient history on the island, and the second was related to a more direct, somatic experience of the sacred.

Approaching the remote island of Samothraki by sea, one sees a looming cone-like shape that reveals its rock masses and ridges as the ship sails into the island's only harbor. The mountain is called Fengari, Mount of the Moon. The sanctuary on the north coast, where the famous *Nike* or *Winged Victory* was found in 1863, is bordered by two long ridges that rise steeply. Depending upon one's vantage point, the five-thousand-foot mountain appears as either one or two peaks.

One morning I was given directions for walking the few miles to Paleopolis, site of the ancient mysteries and ongoing excavations. Although the date of the earliest uses of the sanctuary remains uncertain, ceramic inscriptions have been dated to the fifth century BCE. During classical and Hellenistic periods, the Samothracian temple complex and its mysteries were widely known and attracted numerous participants and visitors. In 84 BCE, the site, also referred to as the Temple of the Gods, was badly looted by pirates. And a major catastrophe, probably an earthquake, caused extensive damage. But the sanctuary buildings were remodeled, and the site flourished until the late fourth century CE, when political and religious pressures forced it to close. Careful excavation and study of the site have been underway since 1938.

I stopped at the Hotel Zenia in Paleopolis to leave a note for Dr. James R. McCredie, the archaeologist who was then leading the excavations. He was to arrive later that week, and I hoped to talk with him. Finally, thinking that I was following the trail to the site, I began walking. Struggling through scrubby brush, I followed a small herd of goats. A startled hawk flew, squawking, into the air. I pressed through brambles and finally reached a clearing, where I caught sight of the Hieron, one of the largest remaining structures. I realized that I had not been on the trail at all and climbed over a fence that encircles the present excavations. Inside the sanctuary, it was quiet except for cicadas, bees, and flies. The sky was gray, the sun obscured by clouds. I meditated for a long time beside the Sacred Rock, a large outcropping of blue-green porphyry, experiencing the joy that accompanies simple, mindful presence.

Archaeologists present a complicated picture of what occurred at the site. In the earliest mysteries, a plurality of deities was grouped around a central figure, the Great Mother, whose antecedents in Greek and Phrygian mythology were Rhea, Hecate, Aphrodite, and Cybele. Later, after the Hellenization of Samothraki, the familiar Demeter-Persephone-Hades triad can be identified. According to Karl and Phyllis Lehmann, the cult included many elements characteristic of other mystery religions: sacrifice of animals, libations, prayers, vows, processions and ritual dramas, votive gifts, and initiation rituals.

Hans Gsaenger, a student of Rudolf Steiner, has suggested that the Samothracian cult had both exoteric and esoteric aspects. The exoteric dimension was related to the myths about and rituals for the Great Goddess and the Cabeiri, her attendants. The esoteric dimension was more concerned with the correlation of spiritual and physical processes in human development. According to Gsaenger, Steiner was convinced that the mysteries of Samothraki were the source of two important ideas within Western religious traditions: that the essence of human being is immortal and that Nature and Spirit are manifestations of the same substance or process. Not only was nature seen as an embodiment of spirit, and hence revered in all its multiplicity, but humans were also morally linked in this nexus. We still need such an understanding of the world and earth as sacred, as well as attitudes of accountability and responsibility that were cultivated in the Samothracian mysteries.

The *Nike*, or the *Winged Victory of Samothrace*, as she is identified at the Louvre Museum in Paris, was found lying in a ditch at the site, missing

her head and arms. The statue is considered one of the most important artifacts of ancient art history. Made of marble from the island of Paros, the *Nike* is approximately eight feet tall, with large wings that are open behind her. Originally seen as if the figure were alighting on the prow of a large ship, the statue was probably set in a pool of water and overlooked the site. With her right leg forward, the goddess of victory wears a long gown that is pressed against her body, as if in a strong wind. Visible from a great distance, she stood in the portico of the elevated sanctuary of the Great Gods. Interpretations of the actual date of its carving and the purpose of the statue continue to change. Possible dates range from the late fourth to the late first century BCE. It is not known whether the *Nike* commemorated a particular victory, symbolized the modest naval power of the island, or served as a generic symbol of power.

If I had never traveled to Samothraki, I still would have been interested in the *Nike*, and I might have inquired about where it was found. I even date my fascination with writing words in stone from my visit to the sanctuary and learning that the ancient stone remnants have provided vital information about the past. My urge to find out more about the nature of religious traditions and rituals was intensified by my journey there.

During this visit to Samothraki, I stayed in the town of Loutra, at the home of Vassili and Vassiliki. A few days after my visit to the ancient site, Vassili took me to the top of Mount Fengari. He woke me at 5:30 a.m., and I dressed quickly to go. When I saw his mule packed for the journey, I felt dismayed, thinking that he had decided I would not be able to walk. Only later, in our peculiar combination of mime, German, and Greek, did he tell me that his right knee bothered him and that we would take turns riding *moulári*. When we reached the edge of town, Vassili put me on the mule. After initial consternation, I was grateful, for the way was rocky and difficult. Later, he rode. As we approached the tree line, we tied the mule to one of the few remaining oak trees and began the steeper ascent over the rock. We eventually came to the last tree, a majestic old oak, with its huge trunk split open so wide that I could have crawled inside. Scrambling over the bare stone was treacherous and demanded full attention. Forced to concentrate on where and how I placed my feet, I was reminded of the Zen walking practice, *kinhin*.

Midmorning, we stopped for breakfast. Having had nothing to eat or drink, I was hungry and thirsty. After our meal of bread, cucumber, Vassiliki's home-cured olives, almonds, and eggs from her chickens, we headed for the top. I felt gloriously happy as we climbed, hand over hand, looking for toeholds. At last we came to the first of two markers. The airplane from Alexandropolis flew over and we waved. Nearby fighter jets made ominous ear-shattering sounds with their target practice. But mostly there were only the sounds of goats, sheep bells, and the ever-present wind. At the highest point, we ate peaches and sat in silence. Sky and sea were exactly the same hue of blue; the land a lighter gray-blue. I was stunned. Inexplicably, the sheep were silent for a time, and as we rose from sitting, a hawk cried and circled below us. I felt there, as I had at the Paleopolis site, that we live in a magical world of omens, totem animals, and stones that emanate spirit. I could have sat on that mountaintop, motionless, for an eternity.

Our descent was more arduous than the climb. My knees and thighs quivered, and I thought they would buckle as I began to stumble and slip. This was a different kind of trial, one of determination to continue in adversity. Like many experiences of the day, this too seemed a metaphor for all of life. We stopped in a *temenos*, a grove of ten ancient oaks. Vassili wandered off alone. I sat, feeling the sacredness of place, then rose to stand amid the rock. Once there had been a stone building, and remains of the wall were scattered around. When Vassili returned, we continued our descent, untying *moulári*, who eagerly led the way. When we reached the road, it was so stony and slippery that even the mule tripped, and we burst into mirthful laughter.

Closer to town we stopped at a stream to drink and refresh ourselves. It was a curious moment, for although we had been respectfully distant with each other during the day, we had also shared an intimacy that was clearly over. When we walked into the village square, Vassiliki was there, waiting. She spoke to me in Greek, and I responded in English. She pinched my cheek, and I went off to bathe. At the house, Vassili was taking the saddle off the mule, and all I could say was thank you.

Vassili had touched me profoundly, from his first appearance one evening, when he pulled a green pepper out of his pocket and grinned, to his few tears in the garden as we said a final goodbye. "*Sto theo*" (to God) I said to him, as he had said to the mountain when we began our descent. Vassili showed me the holiness of the island in such a matter-of-fact way. Here the ancient oak, here the sacred grove where once a stone building stood, here

Fengari, here the crescent moon, *fengari* too. The beans he planted spiraled up twisted madrone boughs, mini trees of life. There was *moulári*, to whom he spoke with such gentleness. Tree, rock, mountain, moon, bean, mule, human: all living manifestations of being, defined by kindness.

In reflecting on these experiences, I am reminded of Mount Meru. Often depicted in Buddhist thangkas, Mount Meru is the sacred mountain located at the center of the Earth, which serves as the cosmic center of the Buddhist universe. This idea of the center, of a place that offers temporal and spatial ordering, was made explicit for me on Samothraki.

How can one possibly represent such experiences of sacred space and experience of the sacred? Verbal language certainly pales, photographs are never adequate, and visual images only carry a semblance of their power. Nevertheless, I spent many hours drawing and painting watercolors of the sea and mountains. My visit to Samothraki was an allegory: an experience of presence, of the numinous, of mystery and awe in the face of the ineffable. Where you find sacred space will be unique to your own sensibility and experience. The studio is one place to start.

10

The Studio

> ➤ *Create a space, a studio of whatever size, in which to work. If you are itinerant, construct a tool kit and take it with you wherever you go.*

> ➤ *Learn self-discipline. Although it does not guarantee greatness, showing up does mean that you have made time to create.*

> ➤ *You will not find your own voice and vision unless you are present to yourself. Go to the studio regularly, wherever it is.*

> ➤ *Explore the studio as a sacred space for solitude and meditation.*

SOMETIMES A PLACE COMES FIRST, before you know that you want to work in the arts or become an artist. But sometimes a place is instrumental in shaping your aspirations. And so it was for me. I came late to the visual arts, if age seventeen can be called late. I had just returned from a momentous trip to Russia and learned that I was pregnant. Although I completed a successful fourth year of Russian study and a first year of course work at the university, I turned to drawing and design during the lonely period of my pregnancy.

One day, midyear, I accompanied my friend Mardi on an expedition to the ceramics studio in Lawrence Hall at the University of Oregon. She showed me her latest creations and introduced a friend who was throwing

pots. Having never seen a clay studio before, I was intrigued by the flurry of activity. Shortly after that initial visit, I convinced one of the professors to let me into an already overcrowded ceramics class. Earlier intellectual aspirations and career plans had lost their resonance, and I longed to reconnect with the physical world. The ceramics studio became my haven.

Even in the era of production pottery—and the department emphasized this—I used my engagement with clay, earth materials, and fire to study geology, chemistry, astronomy, and physics. Ceramic processes opened a way out and into the greater world. Simultaneously, I began using clay to create objects and images dealing with the inner world, dreams, and spiritual longing.

Our studio was in an old university physical plant. It contained numerous small rooms on several sides, like appendages on a crustacean. Faculty members and graduate students had cubbyholes, and there was a small common room for lunchtime conversation and seminars. Sets of drying shelves divided the room into spaces for different uses. In one recess were large concrete bins filled with clay. We mixed this clay by hand from hundred-pound bags of various powdered clays, kaolin, bentonite, feldspar, alumina, and silica. The clay was supposed to age in the bins, but it was always used before developing enough plasticity. In the basement we stored other materials used for mixing clay and glazes: barium carbonate, whiting, cobalt, tin oxide, and zirconium. Kick wheels, which occupied the center of the largest room, were separated from tables for hand building in another area. Two or three electric wheels stood along one wall. What an inspiration it was to watch Bev Murrow throw "off the hump," making many small pots from one massive lump of clay on the wheel.

The studio was open day and night, seven days a week. During my first tentative visit, I knew that I had never seen such pervasive evidence of human creativity. Later, when I was paid to maintain order in the shop, I faced my first painful lessons in entropy. Yet, I became a regular. I came on weekends and in the evenings to throw, trim, pull handles, paint slip, experiment with glazes, and increasingly, to fire the kilns. A new vocabulary needed to be mastered: *bisque, stoneware, flux, feldspar, red heat, cone ten, pilot, convection*, and *radiation*. When all four gas kilns were alight, the kiln room was like a sauna.

Suddenly the mysteries of the physical world opened up for me. Geology was not an abstract science. A cut in the roadside might yield clay. Clay has special properties, and it is ever malleable. If the shape of a pot is not

right, another can be made. If greenware hardens, it can be soaked down in water. If bisque is fired and not yet glazed, it can be ground up for grog. If fired to 2300 degrees Fahrenheit to become stoneware, it can only be broken into shards and recycled as rock. There was a direct connection between those shards and stone from local basalt columns, which we ground into powder for glazes.

That first visit to the studio sealed my fate, or so it seems in retrospect. My teacher, David Stannard, never wavered in his assertion that a crucial dimension of studio practice involved finding out for oneself what one wanted to do. Many students found his refusal to give direction through specific assignments discomfiting, but for me, his approach was liberating. Later, with professors Bob James and George Kokis and visiting artists such as M. C. Richards, Paulus Berensohn, and Paul Soldner, I continued the process of finding my way with clay, to paraphrase the title of one of Berensohn's books.

In subsequent years, as my work has morphed to include stone and mixed media drawing on paper, I have nearly always had a studio: a table, a room, a small building detached from the house. The 2013 flood in Colorado destroyed my "stone studio," which had become a meditation cabin where I intended to conduct a hundred-day retreat in the winter of 2014. Another building that served as both studio and shop—with all of my tools, supplies, and a lifetime of my own and others' art—was also destroyed, as I described earlier. Losing these two buildings that functioned as studios, plus the entirety of their contents, felt like a massive loss and far outweighed the damage to the site and house. But because I needed to deal with so many pressing logistics of daily life, I did not initially have time to fret about losing these creative spaces. For five months, we rented a house while I looked for another place for us. Eventually, I came to understand that a vessel for creativity in the form of a studio could be constructed almost anywhere.

<p style="text-align:center">❦</p>

Creating a studio provides a rare opportunity to shape your meditation practice and creative work, and especially an opportunity to experiment with integrating them. In 2015, I completed work with a skilled carpenter to transform a garage built in 1952 into a studio. We replaced old single-pane windows with larger energy efficient windows and skylights. We insulated the floor, walls, and ceiling, and we replaced the uninsulated

garage door with a wall and large window. A larger door and ramp that could accommodate stone were installed, along with new sheetrock, paint, and light fixtures. A small efficient heater was added. The new flooring would be able to accommodate a variety of uses. But such details faded into the background as I began to work in this new studio. In this sanctuary, I have continued work on multiple series of drawings about path, place, and time, and my Buddhist practice. Sitting in the space, I notice the display of light and shadow, which changes throughout the day, as does the faint rose color of the walls.

If to be an artist is a spiritual calling or vocation, then the studio is a sacred space, a sanctuary for contemplation and meditation in action. And when art functions as a form of meditation, the studio becomes a shrine room, a place of practice. While it is traditionally associated with particular liturgies and practices, I have begun to consider the fittingness of the "seven-branch practice" as part of my studio work. These seven activities are considered preliminary practices for purifying the mind. They are common to many Buddhist liturgies, as well as prayers such as "Samantabhadra's Aspiration to Good Actions," also known as "The King of Prayers."

The first branch, or practice, is prostration, which is a strong antidote to pride. To me, prostrating is a form of bowing, of offering homage, reverence, and respect, of admitting that my ego is, much of the time, a hindrance. Sometimes I simply bow from the waist as I enter the studio. Sometimes I kneel and place my head on the floor in a three-point bow. Sometimes I make a full-body prostration, with hands, forehead, chest and torso, legs, and feet flat on the floor.

The second branch is making an offering, which is an antidote to greed and attachment. Each day, I light candles and incense to open the altar in my home. I bless the space and make offerings to the protectors. One of my first actions in the studio is to do the same there with candles, incense, and offerings. Having so recently lost my previous studio and meditation cabin, I am cognizant that even this new studio is not permanent. It is a place to work, for now. Hence, I honor this without the intensity of attachment that I felt prior to the flood.

Confession, a form of purification, is the third branch. To acknowledge past negative actions, especially when I have been overpowered by confusion, desire, or aggression, is not to be confused with punishment. Confession is enormously freeing. Freedom also comes through the fourth branch, rejoicing, which is an antidote to jealousy. I rejoice that I have met

the dharma, spiritual friends, and a teacher. I rejoice that my practice path is clear. Jealousy toward or envy about others, what they have or what they have attained, has no place in meditation or studio practice. As artists, we must wrestle with this, especially in relation to the world of art.

The fifth and sixth branches have to do with teachers, including buddhas, bodhisattvas, and protectors. Requesting teachers to remain and to teach is an antidote to ignorance. I cultivate and express gratitude to my teachers for what they offer me now and ask that they continue to teach so that I may continue to learn. Related to this, I offer prayers for the long life of my teachers, which is a way to deepen my karmic connection to Buddhist dharma. Sometimes this is described as supplicating the teacher. I have mused much about the word *supplication*, which I take to mean that I should ask for guidance with humility and an open and earnest attitude. I also think about both of these aspects of the seven-branch practice as related to the role of teachers in the arts, even for a mature artist. For instance, for a decade I have intermittently taken classes with Buddhist artists Robert Spellman, Joan Anderson, and Cynthia Moku. Each has helped me to deepen my understanding of the relationship of dharma practice to my artistic creativity in the studio.

Last, I dedicate the merit of each of these actions to benefit all other sentient beings. If you are not a Buddhist, perhaps this practice does not seem relevant, but its main point is to help us get out of our own self-centered view and think of the good of others. Regardless of your experience or the extent of your Buddhist practice, I urge you to cultivate a good heart as you translate your practice into the studio.

<div align="center">⌒</div>

Learning to question and following one's nose is not the easiest path because signposts along the way are not defined as clearly as when one uses a map. Following one's own path into the studio is rewarding and fosters courage to face the unknown, willingness to take risks, and confidence in oneself. Therefore, be alert to your surroundings.

What kinds of places call out to you? Define a corner of your kitchen or office as your workspace. Even if your responsibilities—parenting, caring for elders, employment—make it hard for you to have extended time in your chosen workplace, do not despair. Traditional models of the male artist in his studio carried the unspoken assumption that he could just

leave other responsibilities whenever desired and close the studio door. But whether you are female or male, if you have disparate demands on your time and attention, available time to work in the studio will probably be fragmented. Perhaps it will be confined to weekends or shorter, irregular periods. Find or create a studio in which to work and go there regularly. Having a place to work will be a significant experience for you, as it has been for me.

In the studio, you encounter yourself on a regular basis. You may, as I do, appreciate the studio as a sanctuary for solitude and contemplation, even as a site for formal meditation. In this private art world you take your seat and begin to work. Still, perhaps your mind hungers for another perspective on the absolute or ultimate reality, the great mystery that surrounds you. You may be at the point where you are contemplating your mortality and death. You may feel religious yearning or great curiosity about deities or about what happens after death. And so, to these themes I now turn.

11

Religion and Spirituality

➤ *Consider what you hold as sacred and worthy of reverence and devotion.*

➤ *If you have not done so already, initiate basic practices of caring for yourself. Explore the healing arts, from massage to alternative medicine. It is vital that you restore and heal your body as you cultivate your spiritual life.*

WE ENTER A MARSH filled with quicksand or begin to slip down a slick, icy slope when we talk about religion and spirituality. Each of these terms is contested. Their meanings vary depending on who is speaking. Definitions are always inadequate. However, unless one is a self-proclaimed secular atheist, most people would acknowledge that each word—religion and spirituality—names an important aspect of life. So I will begin with a few definitions. What I have to say here is meant to be inclusive rather than narrow or academic.

Religion and art are sisters, as anthropologist Clifford Geertz described. They are communal and learned phenomena, and they provide us with vocabularies that shape and are shaped by experience. Both art and religion employ symbols, myths, and stories that operate mostly unconsciously and are embedded in rituals, actions, and institutions. They are dependent on particular contexts or locations and are therefore situational. Because

they share so much, it makes sense for the artist to study cultural history, including religion.

For many people, the word *religion* is synonymous with established religions and their institutions, along with traditional values. In the temple, synagogue, mosque, church, or meetinghouse, the world's religious traditions are lived. Deities are worshiped. Cultural values are inculcated. But it is helpful to remember that the word *religion* is derived from the Latin *religio*, "to fasten or bind together." Religions are thus systems of beliefs and practices that connect us to the world, in particular times and places.

For some, the word *religion* conjures up images of violence and war, of people and nations settled in their own values to such an extent that they are pitted against one another for decades or even centuries. I do not disagree with this assessment, but I am interested in the word for its radical or root connotations. What connects us to others? What binds us in a family, sangha, community, or nation? What binds us as one planet? What connects us to nature, history, and ourselves? Religions try to do this, however imperfectly.

Spirituality is a fuzzy word that seems to mean a more private experience of the divine, however that is conceived. Brought into common usage in the latter half of the twentieth century, the term is often disdained. But again, I would urge you to consider its root meanings. *Spirituality* is derived from the Latin *spiritus*, "spirit" or "breath." The breath, like the spirit, is integral to life. Both are incorporeal and ineffable, rather mysterious. We are complicated bodies, vessels for the mind, emotions, and spirit. We might say that spirituality is what we actually practice.

In unique ways, both religion and spirituality point us toward the sacred. To be sacred, a thing, person, or activity must be highly valued by us, and it must hold power over us. What do you hold sacred or holy? To what are you devoted? For some, the answer will be easy: money and material possessions; status and fame; or awards, exhibitions, and publications. For others, the answer may be more difficult to articulate, for what we hold sacred is usually integrated with our values. Is love sacred? Are our relationships to other persons and animals or to the earth itself sacred?

⤝

For another view of what these terms mean, I offer you a personal point of reference. Because my mother was Catholic and my father Protestant, my

sisters and I were raised in a secular household with no formal religious education. In my teens I read Don Marquis's novel *Archie and Mehitabel,* a collection of newspaper columns he had published beginning in 1916. There I encountered the idea of reincarnation and rebirth for the first time, and I turned this notion round and round in my imagination.

In college in the late 1960s, I took my first yoga and meditation classes, along with a course in world religions. In the mid-1970s, I left graduate study in art to move to the Lindisfarne Association in Southampton, New York, a community founded by William Irwin Thompson in 1972. There I began to practice yoga more formally and to meditate in the Soto Zen tradition under the guidance of Richard Baker Roshi and Reb Anderson. Our study included books such as Suzuki Roshi's *Zen Mind, Beginner's Mind* and Chögyam Trungpa's *Cutting through Spiritual Materialism* and *Meditation in Action.*

After eight months at Lindisfarne, I entered a peripatetic period of travel, study, and developing my art. I lived in London for nearly a year, studied at the Iyengar Yoga Institute of San Francisco, traveled to India to study with B. K. S. Iyengar and his daughter, Geeta, at the Ramamani Iyengar Memorial Yoga Institute in Pune. Later, I was certified to teach Iyengar-style yoga. During this time, besides undertaking sustained practices of care for my body through yoga and working with the breath, I also found fine massage therapists and acupuncturists.

In 1984 I reached a major turning point in my life. Artistic work had led me into compelling historical and theoretical waters. After years of immersion in Asian cultures, yoga, and meditation, I found that my reading and study had finally whetted my appetite to learn more about the philosophical and theological traditions of Europe and the Americas. In graduate school at Harvard Divinity School and Harvard University, I found great satisfaction in reading the treatises of Greek and medieval philosophers and theologians and in trying to understand the intellectual innovations of the European reformations and the Enlightenment. I learned about the history of Christianity, including the uses of and fury about the role of images in worship and culture more generally, reading widely from Plato and Saint John of Damascus to Mary Daly and Judith Butler.

Again, I studied all of the world's religions, fascinated especially by Hindu myths and rituals such as the Durga Puja (which I had witnessed a few years earlier), and by the way Zoroastrian ideas had migrated into Judaism and Christianity. For many years, Zarathustra was assumed to

have taught during the sixth century BCE, along with Buddha, Confucius, Lao-Tzu, and Heraclitus. Based on textual evidence, however, scholars have suggested that Zarathustra actually lived between 1400 and 1200 BCE somewhere on the steppes of what is now Afghanistan or eastern Iran. Given ancient migration patterns in that part of the world, I have wondered what other interreligious influences might have occurred so long ago.

During this seven-year period of study, I also deepened my understanding of Buddhist doctrines and practices. I served as a teaching fellow for a large undergraduate course on five of the world's religions taught by Dr. Diana Eck. As any teacher knows, teaching about a topic is one of the best ways to improve one's understanding of it. I developed tremendous respect for the ways in which religious practice shapes the lives of ordinary people.

Over a number of years, I continued intermittent zazen practice, alone and in a local zendo. I read books by Pema Chödrön and Thich Nhat Hanh, among others, and attended workshops taught by these two Buddhist teachers. I also participated in several meditation retreats at Cambridge Insight Meditation Center with Larry Rosenberg and Narayan Liebenson and read books by Rosenberg, Jack Kornfield, Sharon Salzburg, and others in that tradition. After moving to the Pacific Northwest in 1991 for a university teaching position, I continued to make intermittent trips back to Cambridge to participate in meditation retreats. In 1993, I made a second trip to India with a group of university faculty. I had the opportunity to spend a day at Sarnath, site of the Buddha's first turning of the wheel of dharma. My curiosity about stupas, which resulted much later in a 2013 exhibition of twenty paintings, was stimulated there. Sadly, a planned trip to Bodh Gaya was cancelled due to religious strife in the area.

Throughout the 1990s and early 2000s I was looking for a teacher and sangha closer to my home. I learned of a dharma center located only a few miles from the mountain town in Colorado where my husband and I had moved in 1998. Attending a program there in 2005, I met the Venerable Dzigar Kongtrül Rinpoche and became a formal student immediately. Since then, my spiritual path has involved attending programs and practices, reading and studying Mahayana and Vajrayana texts, daily meditation, extended retreat practice, and service to the Mangala Shri Bhuti sangha.

As is obvious from the above description, my spiritual practice has included yoga asana, *prānāyāma*, and meditation within several distinctive lineages and with a number of teachers. It would be relatively easy to

dabble in a generalized popular Buddhism within American culture right now, especially given the plethora of teachers, workshops, and books about mindfulness and meditation. But I have taken my seat and made a commitment to a teacher and sangha to practice the dharma within one tradition. I greatly value those years of exploration, for I feel a strong sense of fittingness about the path I have chosen.

I suppose that, in the end, it comes down to this: I believe the world is at risk. The future is at risk. Ecological and environmental catastrophes will continue to fuel a critique of modernization and globalization. Ours is a situation of chronic global crises vying for attention. Ongoing war; pervasive contamination of the earth, air, and water by toxic pollutants; destruction of tropical rain forests; extinctions on a massive scale; unpredictable climate change; lack of potable water; overpopulation; the ongoing threat posed by nuclear weapons and nuclear contamination; and biological and chemical terrorism—all of these are well-documented. Clearly, change is essential for human and planetary survival. Our religions and spiritual traditions may be our best hope for generating an adequate ethic of care that is grounded in values like compassion and kindness toward all sentient beings, including oneself. Without making this connection between how we care for ourselves and how we care for others, we may miss crucial dimensions of the spiritual life.

I feel a keen sense of urgency to speak, write, and create in ways that address such perceptions and values. In this context, to consider the question of what you hold as sacred is one way to pose larger questions about the future and about the ultimate as it is connected to the intimate details of daily life. I urge you to ask, in your own way, how might it be possible to resacralize the world, to help make the earth a sacred place? Making art can be a sacred act. For help with this process, a teacher can provide inspiration and guidance.

12

The Teacher

> ➤ *Teachers and mentors can guide you, provide inspiration, and help to shape your vocation as an artist.*

> ➤ *Ultimately, you must become your own teacher—astute, critical, and compassionate.*

"WHEN THE STUDENT IS ready, the teacher appears." This aphorism, which I first heard in relation to yoga and prānāyāma practice, aptly describes the role of the teacher in creative life as well. The emphasis here is on readiness. Do you want help and guidance? Are you ready to learn what another has to teach? I do not mean to imply that you must have an actual person in your life as a teacher. Nature is a teacher, and solitude itself is a teacher. Books and films can teach us a lot. If you do not want a teacher, or if you like learning from books, or if you are far from the places where people who might aid you are located, or if for some other reason you are unable to find a teacher, do not despair. I hope you will find inspiration here for rethinking your relationship with teaching and learning.

There is no road map for how to develop personal vision or the discipline and commitment needed for the creative life. Teachers are not mandatory, but they can help point the way. One of the finest narratives I know about finding and working with a teacher is a chapter titled "You Can't Do It Alone," in Jack Kornfield's *A Path with Heart*. I urge you to read this if you are wondering about whether you need a teacher. Finding a teacher is a mysterious process, especially since the old and honorable

model of apprenticeship has been largely lost. In particular, Kornfield offers wise guidance about the kinds of questions to pose to yourself and what to look for in those who identify themselves as teachers within or outside of traditions. I have no doubt that you will find a teacher if you want one.

Teachers have many styles, and they address distinctive aspects of who you are. In the spiritual life, a teacher may be your guru or spiritual guide, your mentor or friend, and that teacher may be wrathful or nurturing. In the arts, teachers focus on different aspects of the creative process itself, on visual thinking and developing visual literacy, on acquisition of technical skills, on making objects or artifacts, on personal expression or development, and on public achievement. Teachers may be encouraging or didactic, compassionate or harshly demanding, and full of tricks, humor, or surprise.

Perhaps my willingness, even eagerness, to engage with teachers has to do with the fact that I, too, have taught at all levels, from youth in primary school to university graduate students and adults seeking to further their education outside of school. I taught eighth grade humanities, high school art, community college art, university art history and theory, and ceramics, drawing, and design courses. For nearly seventeen years, I taught yoga in a variety of settings, including at Harvard Divinity School.

Through my own training and experiences in these classroom settings, I developed a strong set of values around what it means to teach others. A teacher should be responsive and perceptive, able to help you develop compassion toward your own process. The best teachers help to create a space—call it a sacred space—in which you can create. I believe that it is important to acknowledge and honor our teachers, even to pay homage for what we have been given. My own teachers have had markedly different styles and teaching practices, but they all embody qualities of responsiveness, compassion, and generosity.

<p style="text-align:center">⇨</p>

M. C. Richards was my first significant teacher in the arts, and she fostered my inner life. I met her while still in my teens. She tutored me in the connections of art and life. Her life, published writings, and artistic work continue to provide me with a sense of possibility and a model for the creative life. Her intellectual ancestors, from Antonin Artaud to Owen

Barfield and Rudolf Steiner, also influenced my early intellectual and spiritual development.

At a particularly difficult juncture in my young adult life when I told her that I felt motherless, M. C. said that she would be my spiritual mother. Over the years, we talked about both mundane affairs and the great mysteries. Her ideas shaped my reflection on the metaphors of pottery, centering, the transforming fire, and the relationship of language to feeling, the body, and artistic form. Her musings about aging, homelessness, and living the last phase of life moved me. Spiritually, she embodied a way of being in the world that takes into account the impermanence of things. As my spiritual mother, she was both inspiration and compass. She taught me to listen to my inner voices, to have courage in the face of obstacles, to affirm the artistic possibilities of language, and more than anything else, to find and follow my own true vocation.

Challenging professors such as Margaret R. Miles helped me hone my intellect and develop analytical and critical skills. Under Margaret's tutelage, I studied the history and theory of images within Christianity, Greek and Russian Orthodox icon traditions, and theories of the image within European and American cultures more generally. She urged me to become aware of the messages we receive from images, to question images presented in the media, and to select and develop my own repertoire of images to aid in visualizing personal and social transformation.

Margaret also offered me a powerful example of how to reconcile social and institutional responsibility with the creative drive. More than anything else, her writing contains sustained reflection about how to live with virtue and beauty. What do interdisciplinary commitments *mean* in a life? How can we become answerable for what we see? Read carefully, her many books invite us to cultivate within ourselves a generous and responsible spirit that actively enjoys life. Regardless of whether we work as artists or teachers, scholars or critics, this invitation is a great gift.

Other teachers such as B. K. S. Iyengar and Angela Farmer provided a foundation for later meditation practice. While Mr. Iyengar trained me in intensive yoga asana and *prānāyāma* techniques, Angela Farmer helped me to grow into and inhabit my body. I met Angela in London in late 1975 when I moved to England from the Lindisfarne Association in New York. Subsequently, I studied with her in a variety of settings in the United States, Canada, England, and Greece. Over the years, the focus of Angela's teaching moved from technique to the essence of yoga, from the exoteric to the

esoteric body. She helped form my understanding of meditation by using work with the physical body to move into more refined awareness of subtle energies of the chakras and channels, or *nadis*.

She also shaped my ideas about the role of the teacher. Angela taught me how necessary it is to experience and trust my own somatic reality. I asked her once, after I had been practicing steadily for six years, whether she thought I was ready to teach. She said, "Yes, teach what you know through your practice. Pay attention to your body, to both sensation and intuition. Listen to yourself. Become responsible for your experience, and especially take care not to harm yourself or others. You will learn not to be dependent upon a teacher." Acquiring this attitude from her, I have come, over time, to rely on my sense of inner necessity and direction. Few teachers provide such genuine inspiration to transcend self-imposed limits and foster greater individual integrity.

I have had a number of significant teachers from different Buddhist lineages, including Pema Chödrön, Thich Nhat Hanh, Larry Rosenberg, and Dzigar Kongtrül Rinpoche. While Ani Pema was not the first practitioner with whom I studied, she was in many ways my first formative Buddhist teacher. I read all of her books before I was part of a sangha. I began to understand Buddhist psychology and philosophy through the lens of her books and audio teachings on *lojong*, *tonglen*, fear, and other topics.

A significant turning point occurred for me in the early 2000s when I attended a program with Ani Pema that focused on one chapter of Shantideva's well-known classic text, *The Bodhisattva's Way of Life*. Later, she published *No Time to Lose*, a commentary on the text. At the time, my work as a university department chair in a contentious department had left me full of angst and aversion. Her teachings about the paramita of vigilance or vigilant introspection was absolutely crucial to regaining my equanimity.

During that program, Ani Pema spent a fair amount of time talking about the practice of "remaining like a log." We have many opportunities to practice vigilance and not cause harm in the course of daily life. For instance, when initial subtle perceptions give rise to discomfort and I feel hooked by my own reactivity, I can stop and remain like a log. Or if my thoughts and reactions are already underway but do not yet have a strong momentum, I can diffuse their intensity by remaining like a log. And even if emotions begin to escalate in what is usually a predictable and habitual pattern, it is not too late to interrupt the process by reminding myself to remain like a log. When I feel the powerful urge to say or do something,

which may feel irresistible, I can still stop, breathe, relax a little, and remain like a log. While initially difficult to practice, I have used this powerful instruction about refraining, taming my mind, and acknowledging attachments many times in both my personal and professional lives.

During that program, Ani Pema also mentioned her current teacher, Dzigar Kongtrül Rinpoche. Because she was not actively accepting new students at that time, I was curious to find out more about him. I later became his student.

With Thich Nhat Hanh, I began to understand the complexities of mindfulness. For years I used his accessible primer, *The Miracle of Mindfulness,* to introduce first-year college students to meditation. In the secular university context, I framed this around the need for students to develop increased capacities of attention and concentration. More than once I brought a bag of clementines to class and led them in eating the oranges following Nhat Hanh's instructions. You might try this exercise for yourself.

Pick up an orange and examine the skin—its wrinkles, color, and texture. Peel it carefully and observe how the skin tears. Notice your eagerness about this slow process. Now separate the orange into sections. Pick up a section and place it slowly in your mouth. Savor that first taste and the burst of flavor and texture, and notice how it feels as you swallow. Slowly continue with each section of the orange, one piece at a time, until you are finished. Note your anticipation or wish to hurry the process. When you have finished the last piece, pause. Generate gratitude for the tree on which it grew, for those who nurtured the tree, and for all those who participated in bringing it to you. As you put the rind in the garbage can and clean your hands, observe the sense of completion that arises.[5]

You can bring this level of mindfulness to all the activities of daily life—washing the dishes, brushing your teeth, being present with your beloved. After ten years of teaching this and other contemplative practices in the university setting, in 2013, I published an article titled "The Blue Pearl: The Efficacy of Teaching Mindfulness Practices to College Students," which is deeply indebted to what I learned from Thich Nhat Hanh.

In Cambridge, Massachusetts, I attended classes and a few meditation retreats with Theravadan teacher Larry Rosenberg. Larry had studied with teachers such as Ajahn Buddhadasa in Thailand and Thich Nhat Hanh,

5. See Nhat Hanh, *Miracle of Mindfulness,* 5–6, for his very brief description of this exercise.

among others. He founded the Cambridge Insight Meditation Center in 1985, and this is where I met him. His classes and retreats were focused on practices of *shamatha* (calm abiding) and *vipassana* (insight) meditation. But it was his book on death and dying, *Living in the Light of Death*, that had the greatest impact on me. His detailed description of Atisha's nine-part meditation on death, for instance, was revelatory.

Atisha's meditation, which has been widely publicized in contemporary Buddhist traditions, examines the certainty and imminence of death. A teacher and sage who lived in India and Tibet in the eleventh century, Atisha developed this meditation to be of benefit at the time of death and to motivate us to make the best use of our lives. Over years of caring for dying friends and working as a hospice volunteer, I have repeatedly given this book to friends, and I commend it to you most highly. I also spoke with Larry about my wish for a teacher closer to home, and he encouraged me to form and facilitate a meditation group. As a longtime yoga teacher, this made sense to me. But it was around this time that I learned of the existence of Phuntsok Choling, one of the teaching centers of Dzigar Kongtrül Rinpoche. I became his formal student in 2005.

If you have a significant spiritual teacher, you will immediately understand how challenging it is to adequately express the appreciation you feel about what you have learned and continue to learn from your teacher. Over many years of listening to Kongtrül Rinpoche's teachings, asking him questions during teachings, contemplating the dharma, and meditating, I have learned a lot about Buddhism—and about myself. I feel a strong sense of gratitude to have met this masterful teacher who is so committed to bringing the authentic *buddhadharma* to the West. He came to the United States as a young man, was appointed the Wisdom Chair at Naropa University in 1990, and founded the Mangala Shri Bhuti sangha, which has grown into an international organization with dharma centers in many countries. He now has hundreds of disciples.

The root of the word *disciple* is the Old English *discipul*, which comes from the Latin *discipulus*, "pupil or follower." This is related to *discere*, "to learn." In European languages, the word has a distinctly Christian tenor, meaning "a follower of Jesus." But within the Hindu and Buddhist contexts, the unique *guru-chela* relationship is defined by respect, appreciation, and devotion. While you probably have a commonsense understanding of what it means to respect and appreciate a teacher, the nature of devotion

is complex.[6] Vajrayana Buddhism places great emphasis on the teacher or guru as essential for evolving on the dharmic path. The guru functions as a kind of conscience and mirror for the disciple, helping her or him to surrender old habits, especially those related to cherishing and protecting the self. Without releasing this ego-clinging, I cannot proceed on the spiritual path.

Under Kongtrül Rinpoche's tutelage, I read classic texts of the Mahayana and Vajrayana lineages—books by Nagarjuna (c. 150–c. 250 CE) and Chandrakirti (c. 600–c. 650), Shantideva (685–763 CE) and Longchenpa (1308–1364), Patrul Rinpoche (1808–1887), and Jamgon Kongtrül Lodro Taye (1813–1899). I received pointing-out instructions from him—direct guidance for glimpsing the nature of my mind—as well as instructions on how to practice. He encourages all students to maintain daily practice, as well as to undertake retreat. Thus far, because of the outer circumstances of my life, especially continuing care needs of my husband, this has mostly been limited to home retreats, including several of one hundred days. But I aspire to carry my practice into greater solitude at some point. Although he has a reputation for being demanding, Kongtrül Rinpoche has been kind and generous in engaging my many questions and comments, and especially in urging me to see great adversity and loss as opportunities to simplify my life and make a fresh start.

Over years of study and practice, I have been introduced to practices related to specific deities, each of which embodies particular qualities of heart and mind. Long ago, I learned not to reify these beings that are presented in thangkas and sculptures to aid visualization practice. There are many ways to conceptualize deities such as Guru Rinpoche and Vajrayogini, Avalokiteshvara and Tara, Manjushri and Achala, Ekajati and Duthro Lhamo. I remain agnostic about whether they exist on an invisible plane, but I know that they each embody particular qualities of wisdom, compassion, skillful means, and protection that can be cultivated within ourselves and nurtured through meditation practice.

Communicate with your teachers. Initiate dialogue; discuss what you genuinely think and feel. Consider your motivation. Notice your tendency to seek validation rather than embrace challenges to your ego. Be authentic in expressing yourself. Ask questions. As an artist, you will be shaped by

6. For an eloquent description of this process, I recommend Mattis Namgyel's chapter "The Perfect Teacher," in *Power of an Open Question*, 97–104.

many experiences and people. Let your spiritual, intellectual, and physical lives be affected by the elders and mentors you encounter. As happened for me, some of your art teachers may become spiritual teachers. Teachers can be spiritual friends, and they may become your gurus. Choose them carefully and respond attentively to their offerings, because they will have a huge impact on your development.

Using images of your teachers and of these deities is one way to cultivate your inner guide. In one of the frequently recited prayers of the sangha, Kongtrül Rinpoche wrote "May I meet my own inner wisdom guru." This reminds me of Angela Farmer's instruction about the importance of becoming my own teacher and of the Zen Buddhist saying that the final job of the teacher is to free the student from the teacher. While the outer teacher remains crucial, I believe that the point of meditation practice is to recognize and embody this inner wisdom mind in much the same way that we embody the qualities of the enlightened beings we visualize. Ultimately, they will help you to find your own inner teacher. If you practice within a particular lineage, to cultivate your inner teacher does not mean abandoning the tradition with its values and processes. We do not make up practices, or throw out what we dislike, or simply follow our preferences. But it does mean acknowledging and employing your inner teacher as you practice within your lineage.

This concept of becoming one's own teacher, of meeting your own inner wisdom guru, as my teacher put it, is complex. Having been a teacher to so many others during my adult life, I have strong views and values about what education is and could be. The root of the verb *to educate* is the Latin *educare*, which means "to draw forth or lead out." I believe that a fine teacher draws forth what is nascent in the student, helps her recognize and honor her ideas, and helps him assess the potential consequences of creative choices. In this process, fostering independence is crucial, as the American pragmatist Ralph Waldo Emerson wrote in the essay "Self-Reliance." "What I must do is all that concerns me, not what the people think . . . It is the harder, because you will always find those who think they know what is your duty better than you know it. It is easy in the world to live after the world's opinion; it is easy in solitude to live after our own."[7] Emerson instructs us that a great person maintains the independence of solitude even in the midst of a crowd.

7. Emerson, "Self-Reliance."

All of this requires cultivating inner balance. I'm thinking here of a balance beam, which I have used, or a tightrope, which I have not. We need to learn to walk the middle path between blind acceptance of others' ideas that are part of a lineage or tradition and rejection of traditional norms and standards. As Kongtrül Rinpoche wrote in *It's Up to You*, "On the path of self-reflection, you are the ultimate assessor of the beginning, middle, and end of your journey."

13

Mind Training

➤ *Training the mind has to do with developing new habits of openness and stillness.*

➤ *We are already well trained in self-cherishing and ego-clinging. Observe what happens when you release these habits, even in small ways.*

YOU MAY THINK OF READING and studying history, philosophy, and theory as the usual ways of training the mind, especially because we hone our intellectual knowledge and acumen by studying these disciplines. But there is another—more direct—means of mind training that has to do with calming the mind and taming the wild mind with its aggressive, distracting, and painful thoughts and emotions. The methods for this training have little to do with religious doctrine and dogma and everything to do with mindful attention and concentration. If we cannot calm the mind, we cannot do anything with it, including work effectively in the studio.

This may, in itself, be a challenging instruction for you, especially if you are already infatuated with the frenetic pace of contemporary life. But more than anything else, mindful breathing and sitting meditation help to relax and focus the mind. Your creativity will become more accessible to you. There is remarkable continuity among Buddhist lineages on the importance of working with the breath and the techniques for doing so.

I recommend that you experiment with each of the following exercises whether you identify as Buddhist or not.

‹Ə›

In sitting meditation, mind training begins with the "six points of posture" because posture is crucial to the flow of energy in both the body and the mind. First, to establish a stable *seat*, sit at the edge of the chair. Second, the *legs* should be neither crossed nor stretched out. The feet are directly under the knees. Third, the *hands* are placed, palms down, on the legs. Fourth, the *torso* is relaxed. The spine should be straight, tilting neither to the front nor back and neither to the left nor right. Fifth, the *eyes* are kept open, gazing down at a spot about three or four feet in front of you. Finally, the *mouth* should be slightly open, tongue resting against the upper palette. Will Johnson's *The Posture of Meditation* is a useful practical guide on how to sit for meditators in all traditions.

After adopting the six points of posture, bring attention to your breathing. Observe the sensations of the breath in the abdomen, the diaphragm, and the lungs, or focus on the light touch of air as it enters the nostrils. Then begin to count the breath: on the exhalation, one; next exhalation, two; and all the way to ten, twenty-one, or 108. Then start again. If your mind wanders frequently, keep bringing it back to the beginning, to one. Eventually, this counting will become automatic or unnecessary.

Depending on your state of mind, your attention may wander in either mild or wild ways. As you observe the mind, you might name what it wanders to as "thinking" and come back to the breath. While your mind may seem impossible to tame, at times you will be able to rest in a quiet and calm state that is refreshing. Look dispassionately at the reactions and habits of the mind. Once you have practiced focusing on the breath, you might experiment by using bodily sensations or sounds or by watching thoughts as the point of concentration. This simple yet profound practice is called *shamatha*, the practice of calm abiding.

‹Ə›

In walking meditation, the focus is on the movement of the body while simultaneously being mindful of the surroundings. Although walking meditation can be effective indoors, I like to practice outside. To begin,

stand briefly to balance yourself and release tension, allowing the arms to hang freely. Instructions are simple: Walk at a slow pace. Place your awareness on one part of each foot—big toe, space beneath feet and ground. Later, you might try to take note of each step as a whole—the lift of the leg, the heel making contact, the roll onto the ball of the foot, other parts of the body, breathing, body temperature, wind on the face, and so on.

Walking meditation helps to quiet and focus the mind, and it provides an opportunity for personal insights to arise. It develops balance and concentration, and it increases stamina for meditation and mindfulness of movement more generally. Walking meditation also contributes to a general sense of well-being by relaxing the body, reviving tired muscles, stimulating circulation, assisting digestion, and minimizing sluggishness.

⟜⟝

As an artist, you must learn how to look and how to see. I learned a set of five practices with the eyes from dancer and teacher Barbara Dilley.[8] She originally introduced them in a 1996 public performance titled *Naked Face*, which was performed at the Boulder Museum of Contemporary Art by the Mariposa Collective and directed by her. They are designed to refine a general understanding and experience of vision. In the first practice, "closed eyes," you focus on resting and refreshing your eyes and consider what internal seeing might mean.

The second practice involves "peripheral seeing." Soften your focus and try to see from the corners of the eyes. Looking straight ahead with a soft gaze, it is sometimes possible to see almost 180 degrees, and this is an exciting expansion of vision. With the presence of screens everywhere, many of us have never truly experienced peripheral vision.

The practice of "infant eyes" introduces the idea of seeing before naming what we see. Is it possible to look at the world as if you have never seen it before? Try it and see.

"Looking between things" offers a direct experience of both positive and negative space. The world is full of objects that define space, while the area between these objects is known as negative space. Often, we fail to notice the unique shapes and forms of this space.

8. Dilley, *This Very Moment*, 122–24.

Through "direct looking," you learn to investigate and absorb the images and symbols in a work of art. Sustained visual study and reflection can often yield surprising questions and insights.

After experimenting with the five eye practices, you might appreciate the practice of "beholding"—experiencing a work of art firsthand. Find a drawing, painting, print, photograph, or sculpture that you can pick up. Hold it in your hands and get close to it. If you are in a museum or gallery where you cannot touch the art, then get as close as possible to examine the object in detail. Sometimes this results in an experience of tremendous intimacy, and you feel awed by what you see.

Beholding is a counter both to the usual two-second walk-by experience that characterizes much museum looking and to the analytical dissection of a work of art. These methods of viewing art are not intrinsically wrong, but thoughtful beholding often leads to another kind of encounter. My own love of Buddhist thangkas and Islamic manuscripts and calligraphy, for example, has grown from this kind of sustained beholding in museums. Historical study is crucial, but it is not the same as beholding, which is a first-person experience of actually looking at a work of art with full attention.

⊖

Sensory perceptions and impressions are a form of wealth for all of us, whether we have any inclination toward the visual and performing arts or not. Ours is an ocularcentric age, focused on vision and the visual, and we are therefore experienced in using the eyes. But what happens if you let the ear be the main organ of perception as you relate to the world? How do we tap in to inner sources of creativity? We do so through receptivity, inquiry, and listening. From the Greeks to contemporary mystics, the ear has been as important as the eye. The most obvious way to engage in deep listening is through music, but you can also sit in nature and attune yourself to the myriad sounds around you. Habituated to hyperstimulation, many of us listen to music all the time and talk on cell phones when we are walking or even while having coffee with friends. Learning to listen effectively and *hear* has tremendous implications for your life as an artist.

Working directly with the breath and the senses can also have surprising impacts on the ways in which we cherish and protect the self. Most of us keep a very tight hold on this sense of ego, of who "I" am, of what belongs to

"me," and what is "mine." But these ideas are not quite as solid and permanent as we might think. A significant part of what I have come to see is that this self is highly dependent on conditions that arise, and that my thoughts about who I am are impermanent and malleable. In Sanskrit, the word for this is *pratītyasamutpāda*, which means "dependent arising."[9] Everything arises and vanishes as part of complex interdependent processes. Like all phenomena, the self is also a construct subject to change and transformation depending on causes and conditions. When I left Jamestown and performed a ritual in honor of closing my time at This Place, I found that what I was attached to in the past ceased to hold the same power in the present.

<center>⌁</center>

When I began breath work through yogic and Zen meditation practice, my body was young—strong, yet tight. My mind was tense and anxious. Now, through decades of experience with the disciplines of yoga asana, *prānāyāma*, *shamatha*, and other meditative practices, my mind is stronger and suppler, while my body is aging.

Reflecting on this, I am reminded of a story about a conversation between the Buddha and a monk named Sona, who had once been an accomplished vina player. (A vina or veena is an Indian stringed instrument.) The monk was subjecting his body to extreme austerities and was frustrated by the lack of results from this training. He was visited by the Buddha, who asked, "When the strings of your vina were very tight, could you play it well?"

"No," Sona replied.

"When the strings of your vina were very loose, could you play it well?" the Buddha then asked.

"No," Sona again replied.

"But when the strings of your vina were neither too tight nor too loose but more balanced, could you play it well?" the Buddha asked.

"Yes," said Sona.

"So," the Buddha said, "our meditation practice should not be too tight or too loose!"

9. In *Logic of Faith*, Elizabeth Mattis Namgyel offers clear descriptions of the meaning of this complex term.

There are much longer versions of this story, but this is, for me, a vivid description of Buddhism's Middle Way. Not too much and not too little effort: this is how we should train the mind.

FIGURE 14

14

Meditation and Art

➤ *Always return to practices of mindful attention, to observing the world as it presents itself. Discipline yourself rather than being disciplined by others. Establish a daily contemplative practice on five or six days a week.*

➤ *Let your practice inform your art; let your art become a form of meditation.*

MAKING ART CAN HELP you center yourself, can focus your attention, and can engage all dimensions of your life with mindfulness. The same is true of meditation. If you already have an established contemplative practice or if you are familiar with these ideas, I recommend skimming through what follows. Build on what you already know, use the practices that you have been taught and to which you feel connected. However, you might well ask what I mean by this phrase, contemplative practice, or you might be curious about meditation itself. If so, read on.

What impels us toward a spiritual path? As His Holiness the Dalai Lama has repeatedly said, all sentient beings want ease and happiness and want to be free from suffering. But to achieve this state, you must know yourself. Within Greek culture of the seventh and sixth centuries BCE, the phrase *know thyself* was reputedly carved in stone at Apollo's temple in Delphi, and it has been attributed to both pre-Socratic philosophers such as Thales and Heraclitus and later Greek philosophers such as Socrates

and Plato. In India, this admonition also appeared in the Upanishads, which date from an analogous period, approximately 700–500 BCE. But regardless of its origins, the exhortation to study yourself and to practice self-reflection is a common thread that runs through many traditions, including all Buddhist lineages. To study oneself means to look honestly and without judgment at what arises in your life and in your mind.

Meditation is a path to knowing oneself. There are many forms of meditation: prayer and mindful sitting; singing and chanting; movement such as yoga, chi gong, tai chi, liturgical dancing and walking; and focused experience in nature. Traditionally, there are four major postures for meditation: sitting, standing, lying down, and walking. Meditation in each of these postures will be beneficial for you in numerous ways. It will foster calm and reduce stress, increase awareness of the present, enable you to better question and explore your assumptions about yourself and your art, and help you understand and know, viscerally, the interconnectedness of life. Ultimately, meditation can help to deepen your sense of the Four Immeasurables—lovingkindness, compassion, joy, and equanimity.

I find it notable that a split between contemplative traditions and academic study occurred in European traditions in the twelfth and thirteenth centuries when universities consolidated their curricula as separate from that of monastic and cathedral schools. But in parts of Asia, in Buddhist India and Tibet, for example, such a separation did not occur. There, religious education, instruction in meditation, and academic study were all part of one's overall education. My own educational and artistic ideals see spiritual development as fundamental, the foundation upon which acquisition of knowledge, conceptual and critical thinking, and technical skills are built.

Most of us need a period of exploration to ascertain what we might do. So explore the resources that are available to you. But whatever you choose to do, integrate your practice into daily life. Develop your own methods of accountability, which might include talking with a friend, keeping a journal or daily log, or working with a teacher on a regular basis.

Even if your art is not figurative or representational, meditation will help you develop the ability to observe yourself, others, and the world and to attend to all of your senses. Such practices are directly related to developing self-discipline, which will have a profound effect on your art practice. The ability to observe, to stay in the present, and to pay attention to passing sensory impressions are essential for an artist. Contemplative practices of all kinds are also deeply related to other practices of self-care, and they can be a vital part of healing the body. We are carnal beings, embodied spirits,

vulnerable to all kinds of illness and debility. And especially given the information overload and speed of contemporary life, meditation helps to quiet the inner and outer chatter so you can listen to yourself and increase your ability to visualize and imagine.

As I described earlier, I have had a meandering spiritual path through yoga, *pranayama*, and meditation training in Theravadan, Mahayana, and Vajrayana Buddhist lineages. These traditions offer many ways to heal the body and train the mind through both form-based and formless practices. What have I learned, you might ask, through these years?

I learned to pay attention to deep inner experience: the obvious physical sensations, as in the spine, pelvis, or upper torso, and the subtler feelings of openness, vulnerability, and surrender that arise as one breathes life into dull or once dead areas of the body. I learned to concentrate awareness in the *hara*, the belly, to awaken dormant energy, to discover the locus and source of the vital life force.

Like the sound of a Tibetan bowl gong, certain images that I first heard described by Angela Farmer resonate in me. The sternum flies or opens like a flower toward the sun, or *is* the sun. The breath is like an ocean wave, each inhalation a moment of quiet, each exhalation an extension, release, surrender. The body is like a tree with roots, trunk, branches, leaves, and flowers. We stand, planted firmly, gently moving in the breeze. The spine is like the tail of a kite, where light and space inhabit the vertebral interstices. We are at once trees and Greek or Egyptian statues, majestic in our utter presence. Each of us is an axis mundi, a central pole that connects the earth beneath us, the ground on which we stand, and sky above.

Preparing for an asana is like cleaning one's house before a guest arrives or like being a surfer awaiting the wave. If the preparation is done, if the body is quiet, then a sudden release may take place, and one can ride the release like a wave. You just have to wait, letting go of all your ideas about the body. Finally, through the process of becoming aware, undoing tightness, and releasing tension, I have gained a sense of autonomy.

These insights have affected every aspect of my creative life, as well as my readiness for formal meditation practice. The first of the Yoga Sūtras of Patañjali is *yoga citta vrtti nirodha*: yoga is the cessation of the modifications of the mind. My path into formal Buddhist meditation began with sustained yoga practices. This path is not for everyone, but given my disposition and karma, it has been fruitful for me. The process of individual transformation is a lifelong journey, and you can begin now.

ᛣ

In addition to undertaking meditation, have you actively considered art-making itself as a form of spiritual practice, with both inner and outer dimensions? Traditional artists engaged in practices of inner purification through the work, cultivating values such as attentiveness, detachment, patience, humility, and silence. But the artist was also giving form to religious and moral teachings. Therefore, the work expressed a calling, a vocation, to make spiritual teachings available to the public. For artists already interested in or committed to a particular spirituality or practice such as Christian prayer, Hindu, Buddhist or Taoist yoga, or Buddhist meditation, this interpretation of art as spiritual practice might be easily incorporated into a working process.

Many secular artists actively repudiate any form of organized religion. Nevertheless, this inner dimension of art is readily accessible to all artists. What if, as a regular part of studio education, artists were taught how to be silent, how to meditate, and how to learn techniques of visualization? Stillness and silence allow you to experience life at a different level, to listen not only to yourself, but also to the many other audible and inaudible voices that surround you. Values of attentiveness, acceptance, and contentment can be fostered through such practice as well.

FIGURE 15

Sometimes, making art has a clear meditative intention and view. So it was, for instance, in 2006 when I began a series of drawings titled *Meditations on Impermanence*. This series confronts the nature of transient

experience. Some works explicitly reference ephemeral natural phenomena such as flora, fauna, and various manifestations of water, especially clouds, snow, and ice. Others deal with the profound experience of impermanence as it manifests in illness, aging, and death. The experience of place is a powerful reminder of impermanence, yet being-in-place also provides solace in the face of suffering and loss. This drawing, titled *Meditations on Impermanence #1*, is the first in the series. The repeated urn forms acknowledge the inevitability of death. The process of creating it—of studying clouds and water, of using the urn forms to contemplate suffering and death, grief, and loss—was, in itself, a profound meditative practice.

<p style="text-align:center">⊸⊝</p>

If this idea of art as a spiritual practice appeals to you, I urge you to read such books as Nancy Azara's *Spirit Taking Form: Making a Spiritual Practice of Making Art*, Michael Franklin's *Art as Contemplative Practice,* or John F. Simon's *Drawing Your Own Path.* It does not matter if you have ever studied art or if you are an accomplished artist. Azara's, Franklin's, and Simon's exercises and meditations will guide you adeptly into this arena. To make art that is influenced by your contemplative experience, meditation, and prayer, and to make art as a form of spiritual practice in itself: these might be seen as two sides of a coin. Meditation and art are two interdependent faces, but the coin is one.

15

Whose Tradition?

➤ *Study the arts of various cultures across time. Find out what compelled people to create in other times and places.*

➤ *Knowing about the past will aid you in dealing with the present. You cannot create the new in a vacuum. You may find particular cultural traditions emerging in surprising ways in your own work.*

➤ *In your creative work, take risks. Do not abandon your own or others' traditions completely, but experiment and play with images and symbols to surprise yourself.*

HOW DO YOU LEARN cultural history? And more to the point, whose history should you learn? There is no simple answer to these questions. You can learn social, political, and economic history through the art and artifacts of human invention. You can also focus on traditions close to home and learn their rich histories. You can, of course, choose to be myopic and never learn about others. But I say to you, study the art of the world, of traditions and cultures across human history.

Early in my adult life, the study of Asian art was immensely forma-tive, for I began to understand art as a symbolic system for expressing both personal and cultural values and worldviews. I studied the arts of India, China, and Japan, and then I continued my study of Japanese art with J. Edward Kidder, one of the premier scholars of his generation. Later, I also

spent many years investigating the arts of Europe and the Americas, study-ing theories of the image and icon, and exploring controversies concerning the use of images.

I studied and taught modern art history and contemporary art. Teach-ing world art history was especially formative because through it, I deep-ened my understanding of artistic traditions about which I had previously known only a little.

I read books and scrutinized their images, met people, went to mu-seums to see art in person, and traveled to see art in situ. In particular, two journeys to India helped to shape my understanding of the history and diverse cultural traditions of the Indian subcontinent. Multiple journeys to England, Scotland, and Ireland turned my attention toward Neolithic cultures of the people who inhabited the islands from approximately 4000 to 2000 BCE. Who were these ancient people, and why did they construct massive stone monuments? As I have experienced, cultural traditions and history can become personal through both study and travel, and they may carry special poignancy when they relate to particular life experiences or to one's own ancestry and lineage.

⮹

The purpose of my first journey to India in the mid-1980s was to study with B. K. S. Iyengar at the Iyengar Yoga Institute in Pune. This experience was formative, as I described in detail in *Book of This Place*. Sometimes when I was attending classes with Mr. Iyengar and his younger associates, I experienced moments of a crystalline, nondual awareness, an intimation of the nature of mind that I seek to stabilize through my present meditation practice.

A second trip to India in the 1990s with a group of university fac-ulty took us eastward down the Indo-Gangetic Plain, from Delhi to Luc-know, Varanasi, and Calcutta. I have many memories from these journeys. Among them was the experience of being barred from entering the Durga Temple in Pune because I am not Hindu, of seeing spectacular Mughal art and architecture in Lucknow, and of witnessing the ritual of cremation on the Ganges.

But perhaps the most vivid experience of those two journeys was spending a day at Deer Park in Sarnath, site of one of the largest extant Buddhist stupas. Like the Great Stupa at Sanchi, this is one of the most

revered pilgrimage sites in India. Surrounded by many smaller votive stupas, the Damekh Stupa at Sarnath is massive—128 feet tall, ninety-three feet in diameter, and extending ten feet underground. The octagonal base was originally faced with carved stone, some of which still survives, and niches held life-sized statues. Archaeologists date the stupa to the sixth century CE. To circumambulate such a structure was thrilling and later inspired me to create a circumambulation path in my contemplative garden at Ivydell.

Sarnath is famous because the Buddha first taught before a public audience there following his enlightenment. He taught the Four Noble Truths, known as the "first turning of the wheel of dharma." Put simply, the first of these truths acknowledges that we experience suffering; the second that desire, attachment, and aversion are the cause of our suffering; and the third that it is possible to end this suffering. The fourth truth describes an Eightfold Path, a skillful method for cultivating wisdom, ethical conduct, and concentration.

Sometimes an image has a long incubation in the mind and imagination. So it has been with my obsessive curiosity about the stupa, which originated in an undergraduate course on Indian art when I was eighteen. We studied the Great Stupa at Sanchi, and I later made a series of drawings inspired by it. In graduate school, I studied the Sanchi stupa in depth, including its architecture, iconography, and ritual use. Subsequently I taught about this monument in courses on world art history.

Stupas exist in most cultures of Asia and have migrated around the world with the migration of Buddhism more generally. I have appreciated visiting several major stupas in Colorado, including the large Great Stupa of Dharmakaya, which is located in Red Feather Lakes and holds relics of Chögyam Trungpa Rinpoche. In Crestone, located far to the south, there are several large stupas, such as the Tashi Gomang Stupa with many relics, including those of the Sixteenth Gyalwa Karmapa. Essentially, the stupa is a reliquary, not unlike medieval vessels for a saint's relics, for it often holds the ashes and remains of holy figures, along with other objects. In ancient Tibet—a land of altitude and bitter cold, snow and wind—stupas were sometimes constructed in the landscape to quell natural forces. To me, the stupa is thus an image about death, veneration, and power in nature.

My engagement with stupas continued to intensify during the years of my Buddhist practice. In 2011, while working as a hospice volunteer, I had the privilege of being with a man of one hundred years as he died.

FIGURE 16

We gazed wordlessly at each other until his eyes lost focus and his breathing stopped. A day later in my drawing studio, I mused about how to give form to this profound experience. Suddenly, without forethought, I was making images of Sanchi with eyes and words on the paper. In 2013, I exhibited the fruition of two years' concentrated work painting stupas. The twenty paintings in this exhibition were inspired by three actual stupas: the Great Stupa at Sanchi, the Swayambunanath Stupa in Nepal, and the stupa of Yeshe Tsogyal at Tidro, Tibet, as well as thangka representations of the Stupa of Ushnishavijaya. I also painted "invisible" stupas that are based on a pilgrimage site called Siwatsal in Tibet, where Padmasambhava reputedly placed *terma*, texts to be discovered by later practitioners.

FIGURE 17

Prior to the September 2013 flood in Jamestown, Colorado, I made a small marble maquette of a five-foot-tall stupa I had planned to begin carving that year. An exquisite six-hundred-pound block of marble for the central section of the stupa waited in my stone yard next to the meditation cabin, while the maquette graced the interior space. Unfortunately, I never took a photograph of this sculptural model. All of this stone "went downstream," as we put it, after the flood. To date, none of it has been found in the piles of debris.

I ache sometimes when I reflect on this loss. It is not uncommon for people to use the phrase "written in stone" when they mean that something is permanent. My stonework is inspired by carvings at the Samothracian sanctuary in Greece and historic sites in Turkey. At Samothrace, the only reason we know that women were involved in the ancient mysteries is that their names were inscribed on stone monuments. I always thought of my own marble texts as having some kind of long-term permanence too, but

that naive belief has been replaced by a much stronger understanding of impermanence as the ground of being. The tradition I had studied from my late teens and that I had reflected on for so long found unexpected form in my art. If stupas were essentially reliquaries, then my intuition to use this form to commemorate a death made a lot of sense.

<center>❧</center>

Besides studying the traditions and history of cultures with which you are unfamiliar, you can also learn about the arts of a place based on where your own people came from, the lineage of cultural traditions of which you are a part. While many people would not necessarily feel called to explore their own traditions, I am part of an often uprooted and peripatetic American family that maintained no connection with its cultural ancestry and particular family genealogy. But with the present generation (my sisters and cousins), the desire to understand multigenerational trauma has inspired both our study and a number of trips to England, Ireland, and Scotland.

Because of my interests in investigating place as a formative onto-logical category and in carving stone, I visited a number of ancient stone monuments. While interested in questions about what inspired ancient people to erect massive stones and how they accomplished these feats, I actually focused more on the visceral experiences of standing or sitting beside and walking among massive menhirs and dolmens. It was a pleasure to see Stonehenge before fencing was erected to keep visitors from getting too close to the massive stones. The Poulnabrone dolmen is located in a rocky landscape called the Burren in County Clare, Ireland. Dated as five thousand years old, it is one of the largest and oldest dolmens in the world. Like our bones and the marble I carve, this limestone is also composed of calcium carbonate. With a huge capstone of thirteen by six by ten feet, it rests on three stones, each five to seven feet tall. Now inscribed with con-temporary graffiti in several languages, the stone is worn smooth.

In 2006, I traveled to see a number of stone sites in northern Scot-land. For instance, the standing stones of Callanish on the Isle of Lewis in the Outer Hebrides have long puzzled archaeologists and astronomers, although there is now consensus that they seem to define lunar and solar alignments. They were referred to as early as the first century BCE in a text by the Greek historian Diodorus Siculus. The main Callanish site, which

contains a small stone circle, is unusual because of its tall central stone and well-preserved avenues. During one visit, I sat quietly among the stones on a stunning fall day, watching the sun and clouds create massive shadows. Later, I walked to Callanish II, with fewer stones but of spectacular shapes, and to Callanish III, which is a more complete circle of stones. Nearby, the Achmore Circle, which was excavated in the 1980s, contains only one remaining standing stone, but fifteen other stones are exposed. Clach an Trushal, at more than nineteen feet, is the tallest stone in Scotland and one of the oldest. Composed of Lewisian gneiss that is over three billion years old, the Clach an Trushal is even taller than the Setter Stone in the Orkney Islands. Looking at such stones, I pondered the fact that to remain in place, they must extend many feet into the earth. The effort to place them in ancient times using simple tools and human ingenuity makes their presence all the more miraculous and impressive.

The Ring of Brodgar and the Stones of Stenness are two of the most impressive Neolithic sites on Orkney. Originally erected in the early third millennium BCE, they have never been thoroughly excavated. Mostly these stones are undecorated, but there are a few Norse runes. I visited these two sites several times. On one occasion, I went alone to the Stones of Stenness and the Ring of Brodgar, by bus and on foot, past the Barnhouse and Comet monoliths. The Stones of Stenness may be the earliest henge in the British Isles. Originally, twelve tall stones created a sense of enclosure, but only a few remain standing today. With the Maes Howe burial tomb located nearby, archaeologists now speculate that there was a development from magical practices inside cairns and tombs to outdoor rituals, where religious and other practices focused on sun and moon alignments or the relationships between past and living communities. The theory is that burial tombs opened the Neolithic period in the British Isles around five thousand years ago. This period was closed by stone circles some centuries later. Such configurations of stone may have developed in relationship to landscape or other environmental features, but ultimately they remain enigmatic.

Much less is known about the Ring of Brodgar, as there has been minimal archaeological research and excavation. Possibly associated with commemoration of the dead, thirty-six of the original sixty stones remain in the circle, which has a diameter of approximately 340 feet. Due to nineteenth-century stripping of the site, much evidence about its past has been lost. Like the nineteenth-century Scottish geologist Hugh Miller, I thought the circle looked like an assemblage of ancient druids, mysterious, stern, and

silent. Circumambulating, touching each monolith, stretching my gaze out to the sea that surrounds Brodgar, I found the individual stones, and the circle itself, deeply moving.

At other archaeological sites in the Orkneys, I was fascinated by Pictish symbol stones and stones featuring the ogham alphabet, which is still unintelligible. These stones served a variety of functions—as tombstones, as personal memorial markers, as landmarks showing territorial boundaries, and as public monuments commemorating important events. Dating from the mid-sixth century CE, these stones are much more recent than Neolithic sites like Stenness and Brodgar. The uniqueness of the Pictish stones lies in the visual images that were carved into their surfaces, with distinctive symbols such as animals, mirror forms, crescents, disks, and rods that are difficult to interpret. I spent many hours studying these stones in the Kirkwall Museum on Orkney and the Museum of Scotland in Edinburgh, photographing and drawing them.

Because of the unexpected life changes generated by the Jamestown flood in 2013, I have not been able to use those drawings and photographs as I had imagined. But in 2016, I was inspired to create a small stone garden, not to feature medicinal, edible, or ornamental plants, but to honor marble and gneiss, limestone and fluorite, obsidian and black tourmaline.

My point in describing the experiences of visiting these stones is to encourage you to make a list of places, monuments, and artifacts that fascinate you. Some of these might be related to your genetic lineage, but that is not necessary. Knowledge need not be centered in books, though books and other media are, of course, excellent resources for learning. For me, the experience of being at particular sites served as the impetus for learning about tradition and history, and provided the inspiration for my own creativity. I urge you to use your experiences in the world to do the same.

16

Knowing and Being

➤ *Use information and data to gain knowledge. Do not allow yourself to be seduced by information for its own sake. Wisdom will evolve as you grapple imaginatively with what you learn.*

➤ *Inquire into the nature of reality, phenomenological and virtual. Examine the source of the forces that are shaping your experience as an artist, citizen, and individual connected with others.*

➤ *Think deeply about who you are and who you want to become as an artist.*

How DO YOU KNOW what you think you know? And who are you? Knowing is both a cognitive and carnal process. We know because we are simultaneously body, mind, and spirit. We know through our senses and sense perceptions, through our feelings, through reflection and exercising critical intelligence, and through intuition and insight. Within philosophical discourses, this is called epistemology. And reflecting about who and what you are is to engage in ontological inquiry.

Ontology is the study of what Michael Heim calls "the relative reality of things," differences between the real and the unreal. As you choose creative materials and contemplate engaging with new technologies—from the desktop computer to wearable and implanted chips—cultivate

self-awareness. And if you explore art that is grounded in mind training and meditative practices, as I am suggesting in these pages, notice what happens to your sense of self. Does it seem to become a more hardened and fixed entity, or does it seem to have greater fluidity and mobility? In my experience, the loosening of hard edges in my self-concept and my internal sense of myself has been an unexpected benefit of investigating these questions.

What does it mean to know? Is knowing a cognitive process, primarily linked to thinking? Is it a visual process, dependent upon thinking about what we see? Is knowing intimately linked to sound—including silence, speech, and listening? Is it related to our physical embodiment? These are significant questions for artists because creativity is a receptive process. Normally, we think about creativity as active: the artist does something, makes something, intervenes in the world. But I suggest to you that creativity is receptive. Because of that, you must train yourself to practice self-reflection before translating ideas into action.

If we decide that knowing is most affected by what we see, and if we use primarily visual metaphors, such as "I see what you mean," we encourage distancing ourselves from the object of knowledge. Distance, physical or visual, removes the possibility that subject and object might interact with each other. By contrast, metaphors related to voice and sound encourage another kind of knowing. Aural and auditory metaphors encourage intimacy. "I hear what you mean" suggests closer proximity. It suggests dialogue, not a solitary gaze turned on an object of knowledge. When vision is linked to listening and hearing, we foster greater depth and breadth of perception and intuition. Without examining such issues about how you know, I believe that questions about who you are and what values you hold are spurious.

In particular, ask what it means to know when the technologies that produce information and knowledge are transformed. How does information differ from ideas? What are the differences between data, information, knowledge, and understanding? What is authentic knowing?

Available from a variety of sources and able to be easily manipulated using computers, information is the factual data that surrounds us. Computers are good at storing, retrieving, and organizing data, but they also support a particular model of empirical thinking. Rooted in the early modern European philosophy of Francis Bacon, René Descartes, and Galileo, this style of inquiry focuses on data acquisition, and it valorizes rigorous

interrogation and control of nature through close observation and experimentation. Although this is but one model of thinking that evolved among a few elite philosophers and scientists, its consequences are profound. In every sphere of life, our efforts to control the world have had disastrous environmental consequences.

In addition, our society seems to be about the increasingly rapid collection and consumption of enormous stores of information for its own sake or for entertainment. Unfortunately, as Mark C. Taylor and Esa Saarinen have pointed out, the speed of data access is inversely proportional to the ability to retain and understand what is being collected and consumed. As we increase the amount of information, meaning decreases, and the more information we have, the less we understand what it means. Understanding is, however, not the only casualty of speed. Addicted to the speed of viewing and manipulating images on our devices, our nervous systems cannot slow down. We are too fast for reading. We are too fast for relating meaningfully to other human beings, and certainly we are too fast for nature. Who can really afford the time to watch a heron stalk a field mouse or a garden snake slither out of its skin? Information leaves us gasping to catch our breath.

Ideas are more complex than information. Ideas evolve through the intricate interplay of direct experience, memory, insight, and engagement with the ideas of others. Ideas help us investigate what things, events, and experiences *mean*. Knowledge and wisdom evolve as we grapple imaginatively with ideas.

From one perspective (perhaps a naive one), we might claim exultantly that because of the new possibilities of interactivity and interactive media, we are in a unique historical moment for wrestling with ideas. While information may stand on its own, ideas and knowledge are always intertextual and dialogic. Interactivity seems to present another avenue not only for understanding how ideas evolve, but also for engaging them actively. But at their best, interactive media present opportunities for the viewer and user to make choices that alter their experience with the material. DVDs, podcasts, video games, and YouTube videos, for example, offer minimally interactive choices that are analogous to reading from an anthology. Various forms of menu-driven media offer more choices with links, but the viewer frequently remains a consumer, not a creator. A more compelling definition of interactivity would allow viewers and users to structure their own experiences and thus create new meanings. When communication

is enhanced through choice, control, and direct feedback, interactivity is more likely.

Regardless of the potential strengths of interactivity, you need to ask whether it actually offers true opportunities for participation in creative processes, or whether it is merely a new highly touted form of consumerism. While they are becoming mildly interactive, our digital devices may also be the most effective mode of managing attention that has yet been devised. The screen controls less through its visual content—although that is certainly significant—and more through the medium itself. If these devices have not yet become a mode of surveillance, they are already techniques of subjectification and subjection for the new docile body who lives his or her life behind and through the screen. Sedentary anti-nomadic bodies are easier to control than peripatetic ones. As we sit in front of large and small screens, we risk losing our autonomy. We "interact" but do not actively engage.

I am far from complacent about the possibilities for greater attention to ideas over information. In our world, where everything is simultaneously interconnected and in flux, is it possible that the saturation of the senses with information and data not only cripples but also actually cauterizes the imagination? The image of cauterizing is vivid. Tissue is burned, seared, sealed off. If information saturation cauterizes the imagination, you must pay careful attention to the dangers of data overload and the pleasures of electronic manipulation. These are fundamental epistemological questions, issues that you must address as an artist.

Ontological reflection moves in another direction. What is real? What is the relationship of actual physical reality to virtual worlds? What is the nature of being itself in virtual space? What is the self, and what is it becoming? How are new technologies reshaping individual and communal identity? What does it mean to be embodied in the era of bionics, artificial intelligence, and virtual reality?

Just as the nature of reality is undergoing a shift, so traditional notions of selfhood and community are being challenged by digital media. Computers have introduced the notion of "windows," a vivid metaphor for thinking about the self as a multiple system, as Sherry Turkle has noted. The self does not have a center but exists in separate worlds and plays distinct roles simultaneously. In some cases, we could even say that self-boundaries are erased. Online networks and video games emphasize this plasticity and permeability, while the craze to create home pages and blogs on the web

reflects the desire to redefine the self. Many of us stake out a new territory on the internet. Turkle's use of a real estate metaphor is apt, for it accurately names the way identity is constructed territorially and within a capitalist, consumerist ethos. From the most optimistic perspective, this model of the flexible self, characterized by open lines of communication among its parts, leads to a growing respect for diversity within the larger cultural milieu. Whether this is actually true remains to be seen, and you will have to judge.

Although the desire for self-regeneration and self-replacement—the desire even to escape the body and self altogether—are part of the basic quest for human identity, I must acknowledge that I do not want a cyber-body to replace my physical, sensory body. For decades, I have been committed to the systematic cultivation of the spirit, mind, and body through yoga and meditation. These systems are especially efficacious for restoring the integrity of somatic experience in an era of suffering bodies that may be crippled by their relationships with technologies that blind and bind. From eyestrain and spinal pain to carpal tunnel syndrome, the computer has had an especially strong impact on our physical lives.

Selves can exist in isolation. I am reminded of the role of monastic solitude in Buddhist traditions, where some persons enter retreat for periods of time from a few weeks to years. But this kind of isolation is usually supported by a community. Most of us do not thrive in isolation. Virtual communities offer new avenues for understanding identity, where the truly flexible and multiple self is called to new forms of moral interaction. But cyberspace is also, paradoxically, about separation. Our minds are separated from our bodies. We are physically separated from one another. We are, in the end, separated from the nontechnological, natural world.

What, then, does it mean to be connected to others? What are the ground rules that apply to these new relationships? Interactions in virtual communities are definitely significant, their consequences much greater than simply meaningless diversion or escape. Unfortunately, such virtual interactions may also satisfy our urge for connection without requiring the hard work of direct confrontation and action with, or on behalf of, others. Commonality of interests may substitute for shared long-term goals.

I am certainly not the first to conclude that contemporary digital media challenge our most basic ontological assumptions about the self and world. Some people, and some artists, live their lives increasingly online. What happens to physical phenomena and the natural world when greater value, emphasis, and resources are placed on virtual life in cyberspace? Will the

depletion of nonrenewable natural resources, the pollution of the land, sea, and air, the breakdown and increasing violence of urban centers, the accelerating extinction of species, and even the contingency and fragility of life itself be of but fading significance if we anticipate a future in air-conditioned rooms where all of our interactions are conducted through a screen? Will the external world matter at all once we have created new virtual worlds that do not suffer from these kinds of problems? What happens when the electricity shuts down because of terrorist sabotage or simple overload, as in E. M. Forster's story "The Machine Stops"? These questions, of course, are partly rhetorical. They are meant to affirm that what we value as "the real" has tremendous implications for the quality and sustainability of life.

This phrase, "the real," carries a lot of freight. From a Buddhist perspective, what I am talking about here should be called appearance, the world of conventional reality, which is not quite as solid and real as it seems. The phenomenal world—and indeed everything we perceive, think, and feel—is the product of thoroughly interdependent causes and conditions that we have little power to change. In fact, there are tremendous differences among Buddhist lineages: some are more engaged in political and social activism while others eschew such activity. Like the cloistered Carmelite nun I met one day on her rare bus trip in Boston, some Buddhists prefer extensive secluded retreat. Prayer and *bodhichitta* practice become the dominant form of action on behalf of others and the world.

But whether we call it real or appearance, I believe that nature calls for our engagement. How many of us care to take the time and exert the energy to enter into an apprenticeship with the natural world? Is it not easier to watch the screen than to cultivate a garden? Is it not easier to play video games and surf and shop on the internet than to go outside, find a quiet place, and contemplate the changing of seasons and the cyclical nature of time? Is it not easier to look at YouTube videos of artists and musicians at work than to explore your own art as a spiritual practice?

Time is a formative ontological category, a factor that shapes who you are in the world as inexorably as your relationship to your body, to members of your family, or to beloved others. Willingness to contemplate time can be an antidote to the pervasive speed of daily life. Time is both cyclical and linear. The understanding of time as cyclical is grounded in human sensory experience, in the experience of being an embodied self. Linear, progressive time seems to be based on imagination and thought, on the capacity to remember and fantasize, and hence, on activities of the mind.

For many today, time is teleological, headed toward an apocalyptic end. Life happens in a matrix of time, perceived experientially and understood intellectually.

Our pervasive flickering screens will affect all aspects of cognitive, affective, and physical life for generations to come. We are literally changing the nature of physical existence and reality. How do we develop and maintain a sense of identity when confronted with overwhelming pressures toward conformity and as technology takes over more of our lives? How do we maintain a sense of agency in both personal and public life when these media are so pervasive and present us with so many predetermined options? This is tremendously important for you to consider as an artist. What is your agency as a person? What can you effectively *do*? For some years, I have felt that the greatest contribution I could make at this historical moment might be to act as steward of a small parcel of land. To care for a patch of earth and to learn from it. To observe the seasonal rising and falling of lakes and streams, the flight of birds, and the budding, flowering, and dying of weeds. This is now part of my artistic creativity.

Such processes seem real to me. They occur in what I call "actual phenomenological reality." This sphere is both mundane and extraordinary, for there are few sights more miraculous than rain falling on a stream illuminated by sunlight or a field of blooming dandelions, especially once you know that all parts of this plant are either edible or medicinal. Virtual realities afford other pleasures, of course, and perhaps they should not be compared to sensory experience. In the end, we must remember that realities are multiple.

<p style="text-align:center">⤶</p>

All of the phenomena I am describing here are part of what Buddhists call *samsara*. This Sanskrit word means "journeying," and it refers to an endless cycle of continuous lives through which we are propelled by negative emotions and karma. Believing in an intrinsic self that lives in a solid and permanent world leads to a vicious cycle of suffering. These processes are represented in the *Wheel of Existence* thangka, traditionally placed or painted at the entrance to Buddhist temples. In particular, the movement from birth to death and rebirth is represented as the twelve *nidānas*, or links of dependent origination, which visualize the most fundamental Buddhist ontology.

FIGURE 18

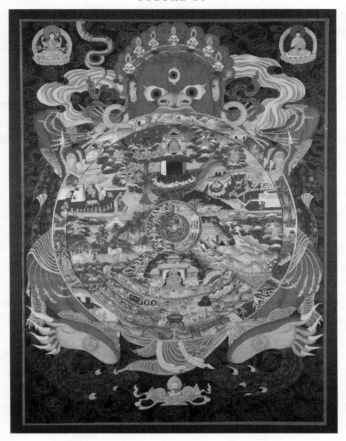

In this large twentieth-century Bhutanese thangka, each of these twelve links is depicted in a unique way. A blind man with a cane follows a woman in the first image, signifying ignorance. In the second, a potter shaping three vases represents karmic formations. These pots symbolize the actions of body, speech, and mind through which he shapes his karma in this wheel of life. The third image is of a monkey that sits in a large tree, representing consciousness. Just as a monkey swings from tree to tree, our thoughts are constantly moving. In the fourth, three people sit in a boat while the boatman moves it through the water, representing the elements that make up our sense of self. The sense organs are shown as an empty house with many windows and a door in the fifth image. In the sixth, a couple embraces under a tree, signifying contact. The seventh image, that of a man extracting an arrow from his eye, represents sensation. A woman

beside her house pours a drink for a man in the eighth image, depicting craving. A man fills many baskets of fruit from a tree, signifying grasping, in the ninth image. Becoming is depicted as the tenth link by a couple making love. Birth, the eleventh link, is shown by a woman on a bed giving birth. Finally, in the twelfth link, old age, death, and rebirth are shown by a woman carrying a baby while birds peck a corpse in the distance.

These images appear as a linear progression that proceeds clockwise in the thangka through twelve stages from birth to rebirth, but in actuality, each *nidāna* is connected to all of the others in an interdependent process, as in this *tsakli* diagram. For instance, ignorance (the first link) is implied in actions being carried out in each of the *nidānas*. Analogously, craving and grasping (the eighth and ninths links) are implied in all of the others.

This thangka and my *tsakli* diagram flow from a particular view of the nature of the universe and of who we are in it, a way of knowing and a way of being. Such art expresses a particular epistemology and ontology. This is heady stuff, but it is also connected to daily life. The images remind us that we journey through the stages of life from birth to death, experiencing suffering and happiness in turns. Liberation from this samsaric wheel of existence is possible, but it requires steadfast commitment to cultivate particular values and virtues.

FIGURE 19

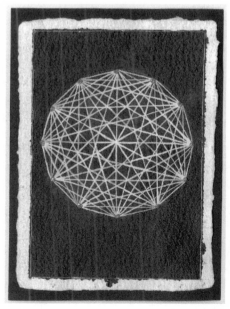

I have thought deeply about such matters and have tried to represent my understanding in my art. You, too, must find your own way to think about what is essential to you, and then bring that depth of awareness and appreciation into your art.

17

Values and Virtues

➤ *Articulate your values, for if you do not know your own ethical standpoint, as an artist you will always be subject to forces outside your control.*

➤ *Creating art can both challenge and depict your values, resulting in new ways of knowing and being.*

➤ *Affirm virtues, such as kindness and generosity, that will remain constant throughout your life. The idealism of such convictions will be tempered by your actual living, but they will provide a moral compass.*

FOR YEARS I HAVE worked intermittently on drawings that visualize my values. Many of these contain multiple layers of writing, overwritten until the text is indecipherable. I drew the relatively small *Metta* in 2002 with graphite sticks while reciting a prayer of lovingkindness. The surface of the 22" x 30" drawing resembles waves or abstract forms. Later, over several years, I worked intermittently on a large 5' x 6' drawing on black paper, which I titled *Prayers: Compassion Practice*. Completed in 2012, its twenty-one layers are composed of three now illegible compassion prayers for myself and others. I began the drawing with a tracing of my body that nearly filled the paper, inside of which I wrote a longer form of the *metta* prayer:

"May I be filled with lovingkindness; may I be well. May I be peaceful and at ease; may I be happy. May you be filled with lovingkindness; may you be well. May you be peaceful and at ease; may you be happy. May we be filled with lovingkindness; may we be well. May we be peaceful and at ease; may we be happy."

FIGURE 20

The second layer of text is a Buddhist aspiration and dedication: "And now as long as space endures and as long as there are beings to be found, may I continue likewise to remain, to soothe the suffering of all those who live." These lines, near the conclusion of chapter 10 of Shantideva's *Way of the Bodhisattva*, invite us to generate genuine *bodhichitta*, an awakened heart that longs to help alleviate suffering in ourselves and others. Like many committed individuals, Buddhist and non-Buddhist, I want my work in the world to serve and benefit all sentient beings.

The top layer of my drawing is a traditional Buddhist refuge prayer: "In the Buddha, Dharma, and Sangha, I take refuge until enlightenment. By the merit of generosity and so forth, may I attain Buddhahood for the benefit of all beings." This mention of "generosity and so forth" alludes to the six paramitas, or virtues, that I aspire to cultivate in this life. The word *paramita* literally means "that which has reached the other shore" or "gone to the other shore." Variously translated, the paramitas include the following: generosity, discipline or vigilant introspection, patience, diligence or exertion, one-pointed attention or meditation, and wisdom. These virtues invite us to go beyond our self-importance and self-involvement, beyond fears and attachments, and beyond habitual ways of thinking and acting. I appreciate this image of the other shore, for it affirms that we need not remain stuck in old patterns of the ego and the small self.

FIGURE 21

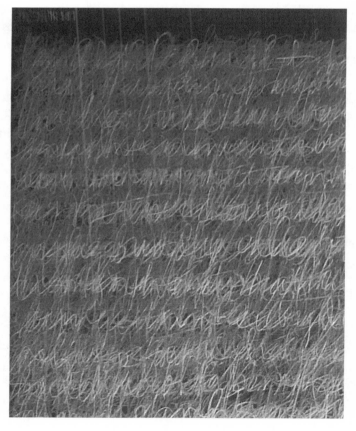

Working on this drawing over months, writing the prayers repeatedly until they were undecipherable, did not diminish their impact for me. Here I was able to create a representation of my values that was deeply satisfying. When it was exhibited in a gallery in Denver, I was surprised by the attention viewers brought to this example of writing-as-drawing.

⊸

Values, both tacit and overt, cut through all attempts to understand the self and the world in many ways. Each of us holds a worldview and ethos, and these shape who we are and how we act. Yet, we may be unaware of what those values actually are, and especially unaware of the dominant values of contemporary society. What action is right in a given situation? To whom are you obligated? How does obligation govern your relationships with others? What is good? How does beauty intersect rightness and truth? What do you hold as holy? What values guide your life? In philosophy, these are axiological queries. Such analyses will help us understand the world in which we live. And it will shape your studio art practice.

An axiological or values-centered analysis of the present might include consideration of concepts such as industrial and postindustrial capitalism, globalism, militarism, patriarchy, and anthropocentrism. Besides simply understanding what such concepts mean as they unfold in the world, you need to ask questions about their rightness, obligation, virtue, beauty, ugliness, truth, and holiness.

For instance, to what and to whom does industrial capitalism obligate us? Or put slightly differently, to what and to whom is postindustrial, multinational capitalism obligated? What virtues are implied in the broad categories of globalism and globalization, which are both economic and military strategies? What truths are affirmed through militarism? Are they selfish? Altruistic? Do they help us consider the well-being of others? Further, how do we measure the relative beauty or ugliness of industrial or infotech centers? From Charles Sheeler to Hilla and Bernd Becher, artists have shown us the stark beauty of industrial forms. But others, such as Mel Chin, Betsy Damon, Agnes Denes, and Dominique Mazaeud, remind us that industrial and postindustrial processes also produce toxic waste that causes disease and disrupts the flow of life in myriad ways.

Or consider the example of patriarchy. Patriarchy describes the ubiquitous hierarchy of privilege that operates all over the planet. It refers not

only to gender hierarchy, which many would say is the first and most pervasive form of domination and subordination, but also to the ways privilege and power are determined by race, ethnicity, class, and other differences. I am perplexed by the paucity of reference to patriarchy in contemporary writing. Have we simply stopped naming patriarchy because it seems impervious to change, or have we stopped naming it because it is so subtly interwoven into institutions, from the family to the corporation and even in the spiritual community or sangha?

Anthropocentrism is the ruling principle that governs most of our thought. As Leonardo's *Vitruvian Man* so vividly depicts, "man" is the measure of all things in most cultures around the world. In her performance piece *filename: FUTURFAX*, artist Rachel Rosenthal depicted a future world where water is scarce, animals and trees are extinct or dead, and life is "dry from virtuality." Rosenthal's text, with its references to the formative modern philosophies of Francis Bacon and John Locke, was a powerful indictment of anthropocentrism. For example, in his 1626 book *The New Atlantis*, Bacon described the technological mastery of nature in what might be called the first science-fiction utopia. For Bacon, the greatest human ambition was to establish and extend the power and dominion of the human race over the entire universe. Locke shared Bacon's ambition. As Rosenthal characterized Locke's view, "The negation of nature is the road to happiness." And we, the inheritors of these ideas, have become convinced that we are entitled to everything—all of nature, all life forms, all of the resources on the planet. Certain that everything should be used for personal gain and to fulfill the desires of those with the most power, we ignore the fragility and finiteness of life. Anthropocentrism is opposed to biocentrism, biophilia, and a wider spiritual identification with all of life.

Some writers and critics have begun to use the term *posthuman* to designate profound changes in our values and experiences. The word was first used by Ihab Hassan in a 1977 essay to acknowledge shifts in human desire and the ways desire is represented. More recently, scholars have analyzed the impact of virtual culture on our understanding of embodiment. From a positive standpoint, this move away from the liberal modern view of the autonomous, rational human self toward the posthuman self presents a new opportunity to understand how our physicality, embodiment, and differences structure identity and experience. Considering ourselves as posthuman holds out the possibility that the pervasive anthropocentrism I have just described might be replaced by something else—not the human

as the sine qua non, but a view that human life exists in a complex interdependent matrix upon which we depend for survival.

Few of us feel intellectually prepared for the challenges of these analyses. Nevertheless, to ask demanding questions about how we know, about reality itself, and about our cultural and personal values is not frivolous. And it is not impossible or impractical for you to become an active public intellectual and media philosopher. I believe that this is one of the most significant directions art education and creative work might take. As an artist and writer, I actively claim these roles, choosing to create in arenas where aesthetic questions are never separated from ethical concerns.

But what *is* ethics? What *is* aesthetics? Both ethics and aesthetics are broad philosophical categories that encompass huge arenas of human experience. In the simplest terms, an ethical system articulates values and rules we hold around "the good" and "the right" in our thought and action in the world. Aesthetic systems purport to tell us about beauty, ugliness, and what we might call fittingness—how well and appropriately things fit together. I presently conceptualize my creative work as an attempt to practice "ethical aesthetics," integrating ethical and aesthetic concerns through my studio practice. Dealing with religious, moral, and metaphysical ideas, linking them to inherited knowledge, reflecting about my responsibility for perpetuating values, and translating knowledge and values into practice are at least part of what it means for me to be an artist who practices ethical aesthetics.

An essential aspect of such a practice is the cultivation of wisdom. Where does it come from, how does it arise, and how do we know it when we finally see it? For a Buddhist, these are complex questions. We all have innate wisdom, too often obscured by the negative emotions of desire, hatred, and ignorance. Buddhists also talk about the three wisdoms that develop through listening to and reading the teachings, through contemplating their meaning and application in daily life, and through meditating. As I mentioned earlier, wisdom is the sixth paramita. Shantideva's last chapter of *The Bodhisattva's Way of Life* addresses the nature of wisdom, including how to develop this profound virtue through meditation practice.

In English, the word *wisdom* is derived from the Indo-European root *weid*, "to see." It means insight into what is true, right, and lasting. But what is it that we *see* when considering wisdom from a Buddhist perspective? We could say that nothing is intrinsically true, nothing is right, and nothing lasts. Shantideva's primary insight is that everything is empty of intrinsic

existence. The self is not permanent and independent. The world is not solid and real. Emptiness is a profound and easily misunderstood concept, but it means, in essence, that everything arises through interdependent causes and conditions, even if we cannot easily identify them.

Waking in the middle of night, I do not muse abstractly about such issues. I experience deep knowing that everyone suffers. I feel, viscerally, the matrix of interdependence that holds and supports me . . . and all of us. I feel deep gratitude for the kindness and generosity of others, and I aspire to extend these virtues to others.

So I issue a call to you, a challenge to face the present and to imagine possible futures. Articulate your values and study the values that shape our cultures. Demonstrate, through your art, what those values are and what they might become. May you find ways to cultivate the virtues you hold most dear.

18

Nature

➢ *Enter into an apprenticeship with nature by paying attention to and observing the natural world.*

➢ *Take the time to learn the lessons of the seasons, of water, of the growth cycles of plants, and of the habits of the animal world. The knowledge you gain from these activities will nourish your art.*

REGARDLESS OF HOW YOU source the content of your art, who you are as an artist will be shaped by your relationship to the natural world. As artist Paul Klee put it, "For the artist, dialogue with nature remains a conditio sine qua non," an essential condition for creating art. It is often said that those who know only their own culture or their own time know very little. The same might be said of the natural world. Knowing the world actually involves much more than travelling or learning about other cultures. Knowing your environment means studying the elements that constitute your place in nature. As artists, it behooves us to remember that we are bodies in a physical environment. I therefore simply want to draw your attention to the physical world. You live in the world of cultures, and you live in nature. Your body is nature, and it is not separate from the physical world. Like the earth, you are made primarily of silica and water.

The word *nature* comes from the Latin *natura*, a verb form of *nasci*, "to be born." In nature we give birth to ourselves, to awareness of change and transformation. In nature we live and die. Raymond Williams suggested

that *nature* is probably the most complex word in the English language. There are at least three related areas of meaning: the fundamental qualities of something; the inherent force that directs all things; and the material world itself. When I talk about "being in nature," I mean this third sense— the physical, phenomenal world.

I have taken lessons about nature and landscape from many teachers and philosophers over the years. The images, metaphors, and exhortations of writers such as Longchen Rabjam and Sir Herbert Read stand out. Longchen Rabjam, also known as Longchenpa, was a fourteenth-century teacher of Tibetan Buddhism. Longchenpa is widely known for systematizing the wisdom of the ancient Nyingma lineage. His biography is a fascinating account of scholarship and teaching, of meditation in solitude, and of activity in the world. His writings on the vastness and beauty of nature as a support for developing awareness of the nature of mind resonate deeply with me.

There are many practices one can do in nature, especially beside water, in view of mountains, and simply under the sky. Sit beside a stream, a creek, a lake, or an ocean and observe the movement and flow or stillness of water. Or sit where you have a view of a mountain. Think like a mountain. Contemplate time, stability, and the utter stillness of being. Stand like a mountain and sit like a mountain in your meditation practice. Be strong and stable, and let the whirling clouds and winds enclose you, freeze you, and heat your core. The mountain, like other elements in nature, is a powerful metaphor for stability, solidity, and quiet. Meditate where you have a mountain in view. Or go to the mountains to meditate, like Buddhist yogis and yoginis before you. Have you ever sat still long enough to really observe a mountain? Mostly, what you will see is that the mountain itself is still amid movement and life that swirls on and around it.

Visit a cave or sit in a cemetery. Let your gaze extend across the vast expanse of a prairie. Lie on the ground under a cloudless sky and open your mind to its endless space. I have always loved watching the sky's changing colors—blues, whites, and grays, from azure to ultramarine—and star dimples at night. I once said that if I could become any element in nature, I would be a cloud, evanescent and transitory, yet present. Try using clouds for the so-called da Vinci exercise: find faces, animals, and things in their changing and ephemeral shapes. Watching the transmogrification of form will stretch your perception and stimulate imagination. Such sky-gazing is a profound form of meditation in Mahamudra and Dzogchen traditions,

where the mind itself is compared to a clear sky. When I undertake such practices, I occasionally enter into a vast, aware, and open state of mind. In these ways, as Longchenpa suggested, nature can inspire the mind to solitude and remind you of reality's fundamental truths.

The twentieth-century English philosopher Herbert Read once wrote that only those who have entered into an apprenticeship with nature should be trusted with machines. Just what might an apprenticeship with nature mean? I believe it means observing the world. It means tending and caring for the land. It means staying put long enough to learn about the environment where you live. Develop a relationship with the place where you live. This may or may not affect your art directly, depending on what you decide to make, but it will thoroughly affect your spiritual, emotional, and intellectual life. And that will find its way into your art. Staying put offers powerful healing from the speed and transience of contemporary life. I find it impossible to either read or write about nature without wanting to be outside. I must sit, walk, and lie down to simply observe the natural world.

Try making an inventory of the natural world close to you. What is it composed of? Is it urban, rural, or suburban? Where does the sun rise and set at the summer and winter solstices? Can you name the edible weeds that grow where you live? How are the elements constituted? How do the winds change, and from which direction do they blow? Find out about your watershed. Where does your water come from, and what is its natural source? Where does your food come from? Note the characteristics of the earth where you live, the topography and geology, the trees and plants, stones and rocks, animals and insects. But do these questions and their answers really matter? I believe that who you are as a person and as an artist will be shaped by your answers to such questions.

What is the quality of the air you breathe? Is it smoggy, hazy, dusty, crystalline, dry, or damp? What about fire? To me, fire is a living element. For decades I have lived in dry areas where fire is a genuine danger. Because of that, I am careful in the winter when I burn branches that snapped and fell during storms and high wind. I am grateful for the heat they bring to the studio where I write, draw, and work on stone.

You might also want to study the work of artists such as John Constable (1776–1837) and Paul Cezanne (1839–1906), whose paintings are vivid representations of the natural world. Constable was one of the most masterful European painters of the sky. He advised artists to observe nature closely and continually and to translate this faithful observation into

finished compositions. Even for Constable, this was an ongoing challenge. Many of his finished paintings took years and were the result of a complex process of development. Cezanne made many paintings of the area where he lived, especially of Mont Sainte-Victoire. These extraordinary paintings made during the final phase of his career are splendid examples of his technique of representing objects and space from multiple angles.

Look at the contemporary work of artists Helen and Newton Harrison or James Turrell for especially sensitive interpretations of their relationship to the physical world. Turrell's *Roden Crater* in northern Arizona, for example, is a massive collaborative project that has been underway since 1974. Or you might look at the way traditional Tibetan thangka painters represented clouds and sky, water and fire.

Try to be like the Greek god Janus, looking inward toward the hearth and outward toward the world. But look outward, toward nature, to consider where you are in a literal way. Consider the meaning of landscape. Natural phenomena constitute a complex and sometimes unreliable reality, as architect and photographer Anne Spirn has noted. Yet that very unpredictability is a powerful teacher. You will always create in an environment of risk, where facing the unknown is a constant challenge. You will be reminded that impermanence is a fundamental existential truth. Nature gives you many opportunities to practice this awareness.

Landscapes can be sites of worship, as at the forest of Ise in Japan, where ancient Shinto rituals are conducted. They can evoke powerful memories, as at Maya Lin's Vietnam War Memorial in Washington DC. For many of us, the landscapes of childhood and youth have particular resonance. For me, certain sights and sounds evoke particular memories of sorrow and joy—among them the sights, sounds, and smells of Puget Sound, the changing tides, and views of Mount Rainier, which often seemed to hover in midair. We play and congregate with others in landscapes, and landscapes are sites of work and of home: the factory, office building, and school; the mountains and sea. Each expresses unique powers.

For most of us, contemporary life is all about speed. Running, bicycling, snowboarding, skiing—activities we think of as recreation—are all fast. Using digital technologies is an exercise in speed. Watching most contemporary film is an experience of action and violence. What, you must ask, actually frees the imagination and slows it down so we can observe ourselves, others, and the world? Stillness and silence. Disciplining the body in nature can allow you to slow down, become quiet and contemplative, listen

to sounds, and notice visual forms and patterns. A few years ago, I spent time observing the habits of a garden snake that lived in my medicinal garden. It was shy, though it sometimes stayed instead of slithering away when I approached. It would raise its head and flick its tongue, sensing and smelling me in that momentary pink flicker. I always felt blessed by these encounters.

Grow something. Plant a seed, sunflower, garlic clove, or tiny lettuce seed. Tend a plant. It will teach you patience. How long I have anticipated the blooming of the snapdragons and the unfurling of the datura trumpet. But I must wait. I learn to slow down, to enter another kind of time. And then, the few weeks when the plant actually blossoms are magical.

Develop your visual memory. When Robert Henri was teaching in Philadelphia and New York in the 1910s and 1920s, he would give students the assignment of studying the model in one room and then going into another room to draw and paint what they had observed. This is a superb practice for enhancing your visual acumen and for exercising the imagination. Nature can be your teacher using this same exercise. Draw that mountain that you have observed or where you meditate. Try to capture the vertiginous rush of water in the stream. Be creative in your investigation.

Without such practices, your art will be like a dandelion seed, wafting on the wind, constantly looking for a place to grow.

19

Taking Your Seat

> ➤ *Commit yourself wholeheartedly to your regular meditation and artistic practices. Do not be afraid of commitment, and do not get into the habit of procrastinating about your work. This is what it means to take your seat.*

> ➤ *Consider breadth and depth. Explore the breadth of the arts and the breadth of your abilities, but let your ideas guide you toward the most appropriate vehicle. Work from the depths of your inner life.*

IN *A PATH WITH Heart*, Jack Kornfield describes a phrase used by his teacher Achaan Chah: take one seat. To take one seat means choosing one practice from among the many distinct spiritual practices of various traditions. It means being willing to sit down, focus on your breath, and encounter yourself on a regular basis. More than anything else, it means being present, practicing.

The artist, too, must find and take a seat. In order to find a seat, a method of working that suits you, you have to explore. Ours is a consumer culture that makes it exceedingly easy to shop around. We are encouraged to try this and try that. It is tempting to make this eternal process of trying the new into a permanent way of working. In art schools and universities, the process of finding your way is made easier because courses in various artistic disciplines are taught regularly. Working on your own, it is more

difficult, for few of us can afford welding equipment, ceramic kilns, and a state-of-the-art computer lab.

But regardless of how you learn about the range of materials and techniques in the visual arts, you will eventually say, "Okay, now what?" This is the time for taking your seat, for settling into the process of finding out what you have to say and what media or vehicles are most appropriate for your ideas.

I find a useful metaphor for this process in the chair itself, and I have explored this metaphor with a broad range of materials, from wood to stone. Some years ago, simultaneous with accepting my first university administrative position, I began to construct small chairs using basswood, glue, acrylic paint, gold leaf, beeswax, and found materials such as shells and old books. I made a meditation chair with a puja table. A work titled *Endowed Chair* contains a small movable text that reads "The vocation of the artist is the reclamation of the future." I also created a series of *Computer Chairs* called *Mercy Seats*, named after an archaic name for the throne of God. Two works of art, each titled *First Chair*, make explicit the fact that the mother's lap is the baby's first chair. A variety of other works are more difficult to categorize. Each small sculpture is a meditation—on dialogue and the way power operates to structure our ability to speak openly and honestly to others, on hierarchy and privilege, on striving and upward mobility, and on meditation, more specifically and literally. When we meditate, we sit in silence, and in our world, silence is rare and hard to achieve.

The chair is like a body. It has legs and arms, a back and a seat. Your body is your chair, the original asana. Asana is a seat on which one sits or any comfortable posture that can be maintained for a long time. It developed from the crouched position common among people who prefer not to use chairs. Therefore, the body is not just *like* a chair; it *is* a chair. This insight, which seems so basic, gave me tremendous inspiration for creating the series and for the creative process in general.

My most vivid experience of using a chair for sustained meditation involved a life-sized marble chair that I carved in 2007. The thirty-eight-inch-tall marble *Practice Chair* rested on a base in an outdoor sanctuary among nine tall willow trees. Four of its faces were carved with text. The seat of the chair read *take one seat,* and the front announced its title. The back of the chair was highly polished, with glittering gold veins. The reverse side of the upright back remained rough, displaying the outline of a snake. I thought of this snake as the naga spirit that resided inside.

FIGURE 22

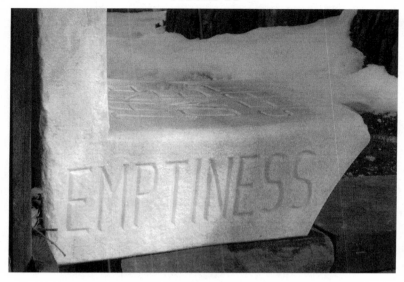

From the time I named it, the chair's title had two meanings. First, this chair was to be a maquette or model for a larger chair that I would carve. In this sense, *Practice Chair* provided me with practice in making a chair. Second, the chair functioned as a place for practice, a seat on which to meditate. In every season, I regularly sat there to observe my mind and the world. Although I would sometimes place a piece of wood on the seat for warmth—thus obscuring the words—I never forgot that I was sitting on *take one seat*. The sheer physical presence of these letters seemed to offer a counterpoint to my felt sense of groundlessness. The chair functioned as a continuous source of inspiration for my daily meditation.

Perching on *Practice Chair*, my right hand would caress the word *emptiness* while my left fingers traced the letters of *no self*. From a Buddhist perspective, the word *emptiness* means that nothing has or carries intrinsic existence. Everything in the universe—persons, events, nature itself—originates through interdependent causes and conditions. Every life is the result of conditions that give rise to the uniqueness of that life's expression in each moment. This principle means that there is no singular or permanent self because all aspects of the self also arise through interdependent processes. There I made a regular commitment to meditate, to observe the world, and give form to what emerged through my art. This is what it means to work from the depths of inner life.

FIGURE 23

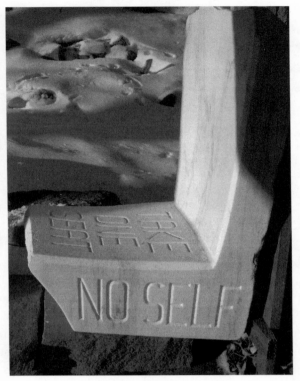

Practice Chair disappeared in the 2013 flood that devastated James-town and our home. It has since become a vivid metaphor and reminder of impermanence and of the need to release attachments and clinging to the self. I was forced to release my clinging to this chair as the support for my meditation practice in nature. Perhaps the greatest lesson of this loss is that I do not need a marble chair to take my seat. Any chair, meditation cushion, or flat rock will do for me, and for you.

20

Art and Life

➤ *Live your life as an art, for the place of art is in daily life.*

➤ *Without connection to life as it is lived, art is meaningless or simply a commodity. Conversely, without art, life remains trivial and mundane.*

➤ *Consider carefully the question of audience and how you will participate in the worlds of art. Determine for whom you make art and where it belongs.*

LIFE IS THE MAJOR art for which we have to learn formal principles, develop technical skill, and hone conceptual acumen. We live knowing that every life has a beginning and expected end. We create art within that fragile and contingent context.

What should be the proper province of art? Art is not an autonomous sphere, unconnected to life, where artists create, viewers view, and buyers buy. Rather, art—and here I mean all of the arts—exists in a profound dialogical relationship with life as you live it every day. As an artist, you engage in creative work within the time and space of daily life. Your artifacts and works of art live in this sphere too. They may, of course, have long lives in cultural history, like the *Nike of Samothrace* or the Russian *Spas nerukotvornyi* icon, or the Ryoanji Zen garden. But even such monuments of world art lived first in the daily lives of their creators and audience.

Obviously, the idea that art and life are connected is not new. A French literary critic coined the term "art-for-art's sake" in 1835. Some European scholars, critics, and artists believed in the sovereignty of the artist, and that the freedom of the artist to address solely aesthetic issues was essential. Such ideas found a particularly influential form in twentieth-century art criticism, and many twentieth-century art movements would claim this lineage. However, there have always been artists, critics, and philosophers who have vehemently argued that art must be connected with life. Robert Henri, Mikhail Bakhtin, and M. C. Richards are but three of those who have spoken and written passionately about this idea.

Robert Henri was a well-known painter in the early twentieth century and one of the best-known teachers of his time. He studied at the Pennsylvania Academy of the Arts and in various ateliers in France. Later, he taught in Philadelphia and New York. His students included well-known artists such as George Bellows and Edward Hopper. He was instrumental in helping to define a distinctly American art for the twentieth century. His book *The Art Spirit* was published in 1923 and contains notes, articles, letters, and talks to students, all of which were compiled by one of his students, Margery Ryerson. At the outset of *The Art Spirit*, Henri wrote that "Art when really understood is the province of every human being. It is simply a question of doing things, anything, well." A person carried by this spirit of art is a seeker who searches, experiments, and invents. Materials are less important than intention. Products are less important than the will to create.

About the same time that Henri was teaching in New York, Mikhail Bakhtin was just beginning to write philosophical essays in Russia. In his earliest essays, written between 1919 and 1926, Bakhtin used the Russian word *otvetstvennost'* to explain the relationship of art and life and of self and other. *Otvetstvennost'* may be translated as "responsibility" or "answerability." Art and life, he claimed, must answer each other. "Without recognition of life, art would be mere artifice; without the energy of art, life would be impoverished." Art and life should respond to each other much as human beings answer each other's needs and inquiries in time and space. Answerability was his way of naming the fact that art, and hence the creative activity of the artist, is always related to life and lived experience.

Recognition of and commitment to answerability does not promise safety and comfort to an artist or to any individual who takes what it means seriously. The way an artist creates, as well as the creative process more generally, expresses deep connection to life. Very often, life events

and experiences determine what you do, although it may sometimes be easier to create if you do not attend to the situation of your life. Works of art live and influence people because they give shape and form to the consciousness of the self in relation to others. Through our creativity, we are inextricably bound to one another and to our environment. Just as no one ever escapes the conditions of contingency and risk that pervade life, so the artist cannot avoid responsibility for her or his actions. Art answers to life and life answers to art. As Bakhtin wrote, "Art and life are not one, but they must become united in me—in the unity of my answerability."

In discussing teachers who were highly influential in my aesthetic and spiritual education, I mentioned M. C. Richards. M. C. is the person who taught me, in person and through her work, about the interconnectedness of art and life. "Life," she had written in *Centering in Pottery, Poetry, and the Person*, "is an art, and centering is a means . . . All the arts we practice are apprenticeship. The big art is our life. We must, as artists, perform the acts of life in alert relation to the materials present at any given instant." Following such guiding principles in my writing and artistic work over several decades, I have become convinced that the place of art is in everyday life.

I agree with M. C. that the arts we practice are apprenticeships for life. Each of us inhabits a unique chronotope, a particular nexus of time and place that is determined by personal circumstances as well as social and political events, geography and topography, and climate. You are a situated being, and all dimensions of your life are influenced by your chronotope. Becoming aware of chronotopic themes and motifs can help to free you and create possibilities for change. If cruelty, distrust, and isolation fuel your life, then they will find form in your art as well. If attention, generosity, and compassion are the values that sustain your daily life, then these too will sustain your art. How you live defines how you will make art.

<center>⟜</center>

As a practicing artist, for many years I have been propelled by the need to express the sacred through drawings, environmental installations, and performances. My art grows out of strong spiritual and ethical values, and I continue to feel an urgent need to formulate a theoretical basis for this practice. As a writer, my concerns have ranged widely. But in both art and writing, I have consistently returned to one theme: to reaffirm the critical and revelatory potential of art within our commodity-driven culture that largely repudiates concern with religious and moral values in the arts.

I believe that the artist has a personal calling, a vocation, to interpret the dilemmas we face, thereby giving voice to hopes and fears, experiences and dreams. If you embrace this view, your art will be oriented to this world, to the present as it moves inexorably toward the future. And it will be active, encouraging your commitment to the world and to the embodiment of values such as love and kindness. As an artist, you are connected to others and to the earth in relationships of profound risk and answerability. Relationships are contingent and relative; they are fragile and always involve risk. But the quality of life, even the continuing possibility of life, is uncertain.

As part of your aesthetic education and your engagement with the worlds of art, I urge you to think about the question of audience. Reflect on the nature of the audience you wish to reach and the most effective strategy for reaching that audience. The past hundred years have been marked by at least two major periods (the early avant-garde years and the present) when the gap between artists and the public has been very wide. If that gap, and the hostility that many members of society feel toward art, is ever to be bridged in even a modest way, then artists must think about who their ideal viewer would be, and who their actual viewers are likely to be. Only when you consider others as an aspect of your own creative process will you be able to break free of stereotypes and pressures to conform within the art world. If you choose to engage the art world in major international cities, from New York to Sao Paolo, Dubai, and Tokyo, you will at least know why this is your preferred audience. Then you can figure out how best to reach commercial galleries and art museums. Or if you choose to give your creative work as a gift, then you will be aware of the nature of that choice as well.

This question of audience is intimately related to the way you understand yourself and your creative process. Many artists today are devoted to art as a form of ego-gratification, with the attendant financial and psychological rewards that may accrue. Such values will probably remain the major motivating factor for many artists because they are so central to what drives American life.

There are, however, alternatives to a practice of art based on self-promotion and personal gain. For instance, you might consider the work of art as a gift rather than a commodity to be sold. In giving a gift, the artist is not necessarily anonymous, but the presence of a second person, and a second consciousness, radically transforms the work of art into a rich aesthetic and moral act. Or you might take Balinese cultural values to heart and affirm

that you have no art, that you do everything the best you can. You might learn a similar idea from M. C. Richards and treat the visual arts as an apprenticeship to life itself. Living and being are integrated with one's art.

I suggest that you ask yourself a range of both conceptual and practical questions as you contemplate such issues. Where is art now and where is it going? What and who defines art? If you want to enter the art worlds of gallery representation, what are the best ways to approach them? What are the benefits and drawbacks of making gallery pieces versus temporary installations and performance art? What are the key legal issues that you must address as an artist, issues such as copyright and contracts? If you contemplate working in a public arena, what are your responsibilities as an artist in that realm?

FIGURE 24

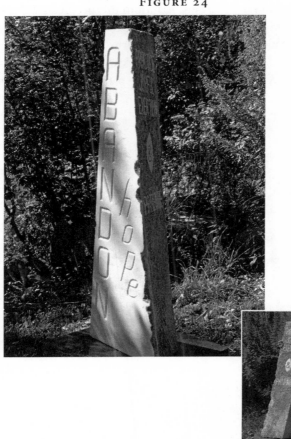

Regardless of how you answer these questions, both art and life are nurtured by solitude and stillness. Seek silence. In the quiet of the studio, you can kindle the imagination. I believe that we, as individuals and as a culture, desperately need the capacity to imagine the future. Art can help us reclaim the future—and the sense that there will be a future—in a time when so much is at risk. French philosopher Gabriel Marcel wrote that hope is a memory of the future. Memory of the future? Through art we can remember and re-member our relationships to life—to ourselves, to each other, and to Earth—if there is to be a future. Hope provides an impetus.

But you might also see the wisdom of one of the *lojong* sayings that moved me to carve the words "abandon hope" on this sculpture. These two words are part of the longer maxim, "Abandon any hope of fruition." To me, this is an imperative to live in the present, clinging neither to past dreams nor future expectations and visions. Art, from this perspective, helps us to fully inhabit each moment with awareness and mindfulness. Art gives form to your life, and your life gives form to your art.

The aspiration and commitment to work with the conditions of your life is the ground. Art is the practice and the path. You are responsible for the fruition.

21

Art as a Path of Wisdom

➤ *Creativity is a dialogical process, like an authentic human conversation. You cannot script it, but it works best when you are attentive to mystery and serendipity.*

I BELIEVE THAT ART and meditation nurture each other and are never in conflict. Spending time with one practice more than the other is up to you. Looking back at the end of one's life, to have forsaken part of one's passion, whether for spiritual practice or for art, would leave a person unfulfilled. Looking back at the end of my life, I will see the path of one who explored the interdependence of meditation and art—of art as a spiritual practice and a path of wisdom. My entire life has been an intellectual and practical exploration of the nature of creativity and the vocation of the artist. All of my published writing constitutes an effort to articulate a theory of creativity that links art to the inner life. I have found great clarification in the Buddhist concept of the three wisdoms—hearing, contemplative, and meditative wisdom—which are used to describe the practice path.

Hearing wisdom is learning though listening and considering if and how what I hear corresponds to daily life. I think that it can also involve looking—studying about and viewing art. It is mainly an intellectual process, involving conceptual mind with its language, images, and forms. Patrul Rinpoche calls it "correctly remembering what you hear." Another way of putting it might be to say that it is learning to correctly interpret what we see.

I was attracted to Buddhist art the first time I saw it in a sophomore art history class, and in particular to the Great Stupa at Sanchi and the Ryoanji Zen Garden in Kyoto. In the mid-1980s, distinguished Islamic scholar Oleg Grabar told my cohort of Harvard University graduate students that regardless of our area of specialization, all of us should learn about at least ten monuments of world cultures and not get stuck in some narrow art historical backwater. I chose to study the Sanchi stupa, Ryoanji, and other monuments in depth, and I subsequently incorporated them into my teaching whenever possible. Decades of university teaching have been a powerful process of consolidating hearing wisdom. One of the privileges of teaching what we know is coming to deeper understanding through this process.

I became fascinated by the material culture of Himalayan Buddhism after a friend brought me two thangkas from Nepal in 1982. A year later in India, I purchased a *Wheel of Existence* thangka that set me on a decades-long quest to fully understand its iconography. Now, a large Bhutanese *Wheel* hangs in my living room, and I contemplate it every day. Yama, the Lord of Death, holds all of this in his hands and feet, a fitting reminder that death is inevitable. Thangkas became my teachers and have led me into deep contemplative wisdom.

Contemplative wisdom develops through deep analysis and examination of the traditions and teachings in relationship to one's own life and to the outside world—essentially internalizing the knowledge gained through hearing and sustained visual study. For several years, I studied traditional thangka painting with Cynthia Moku at Naropa University and in her studio. Beginning in 2010, I did many drawings of Guru Rinpoche using traditional *tigse* or iconometric diagrams. I decided to take my questions about who he was and what he represents into the process of painting Guru Rinpoche. After preparing a frame and canvas, I copied one of my drawings and began to paint the thangka. This is a slow process that will take years to complete. The process itself is contemplative.

Building a contemplative garden at our place in the Rocky Mountain foothills where my husband and I lived for many years also gave me ample experience in moving from hearing to contemplative wisdom. Many questions gripped me. How might my art become an expression of spiritual practice on the land? How could artistic practice become an expression of my inner contemplative life? Over many years, I explored these questions while carving seventeen major marble sculptures with texts and placing them on the site.

For me, death is the greatest mystery and has consistently led me into contemplative wisdom. When I first read *Words of My Perfect Teacher* during the winter of 2006, I was already contemplating the Four Thoughts. Two dear friends I had helped care for had already died of cancer. My closest woman friend, for whom I did intimate care, was actively dying. In an eight-month period in 2005 to 2006, six people in my life died. And in 2006, I began extensive hospice training—about eighty hours with hospice personnel and with secular and Buddhist teachers. During the years that followed, I served as a regular hospice volunteer, both with individuals and families. Care for my husband through the years of his decline with dementia has been aided by everything I learned through reading, listening, and contemplating.

I continue to take my inquiry into study and practice. I regularly recite prayers of supplication and aspiration, work with visualizations, and try to embody the full power of the initiations I have received. I contemplate concepts such as pride of the deity, pure perception, and sacred world. All of this is slowly working on my mind, reshaping my habitual patterns of thinking, creating a small new space for greater understanding.

Meditative wisdom is a deepening of inner experience and understanding through practice, going beyond concepts and simply resting in the spaciousness of the present moment. The goal of this is to learn to let everything arise, whether seemingly positive or negative, and then relate to all thoughts, feelings, and perceptions as aspects of our own mind. As dualistic notions and ignorance dissolve, experiences of clarity and spaciousness become possible. I certainly make no claims to have stabilized my mind in this way, but I can say that it is not quite the same wild mustang tearing around a large enclosed pasture that it used to be. Practicing involves learning how to receive, to let the mind relax and open. The whole question of if and how making art can become an expression of meditative wisdom is deeply engaging, and this remains an open question for me.

When we settled in Jamestown in January 1999, David and I discovered a massive concrete block—two feet tall, three feet wide, and ninety inches long—buried in a pile of junk in a corner of the property. We positioned it along one edge of the garden overlooking the creek and immediately began to call it "the coffin" because it resembled a sarcophagus. After searching for a stone to place there, I settled on a twelve-hundred-pound slab of Italian Carrara marble. Then the challenges began. Because of a number of deep gouges on the surface, the stone was hard to prepare, though I tried diligently to sand

FIGURE 25

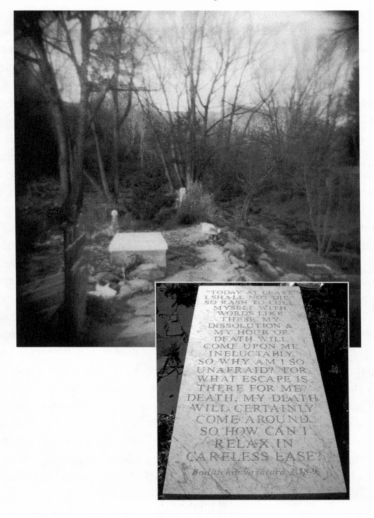

and polish the surface. There were so many letters in my planned text that I knew it would take years to carve them by hand. Finally, I decided to transport the *Coffin* to a monument company in northern Colorado. There we made a template, sandblasted the text, sprayed it with paint used especially for stone, and cleaned it off. The result was astonishing. Words from Shantideva's eighth-century *Way of the Bodhisattva* gleamed, letter by letter, on the gray and white surface: "Today at least I shall not die / So rash to lull myself with words like these. / My dissolution and my hour of death

/ Will come upon me ineluctably. / So why am I so unafraid, / For what escape is there for me? / Death, my death will certainly come round, / So how can I relax in careless ease?"[1]

The process of carving stone is a profound exercise in mindfulness and one-pointed attention. In the end, this stone was, for me, a powerful exhortation to practice. And for years, lying on it was part of my daily practice of making friends with the inevitability of death. After the 2013 flood, I thought that this stone had permanently disappeared, but one day a friend was helping to clear debris and called me over to see a tiny triangle of marble sticking out of the ground. He said, "Let me get a shovel and get this out." I looked at that corner of stone and laughed.

FIGURE 26

We dug the damaged but whole stone out. Another friend later built a sled for it, and then another brought his backhoe to lift the stone from its sandy bed. Eventually, we placed it out of harm's way on an upper terrace in Jamestown. I still miss daily practice with it.

Through carving stone and drawing with water media, I have reflected about another of the challenging questions of Buddhist practice. Before joining the Mangala Shri Bhuti sangha, I asked my teacher Kongtrül

1. Shantideva, *Way of the Bodhisattva*, 47.

Rinpoche a Vajrayana neophyte's question: What does devotion mean? Having been a student of both Theravadan and Mahayana teachers over several decades, I had heard little of devotion. His answer had to do with appreciating and serving the vision of the teacher, as well as cultivating the aspiration and commitment to wake up. This made sense to me.

Devotion has both outer and inner forms. As an outer practice, it has to do with where we put the mind. Ideally, a Buddhist practitioner might focus on the teacher and lineage, on a vision of bringing genuine *buddha-dharma* to the West, and on finding purpose and meaning by being connected to something larger than the self and personal attachments. Inner practice helps us to find and experience the sacred world and the mind's own nature. Devotion is a skillful means to give meaning to and transform one's life, and it is essential for realization.

Devotion is also an antidote to ego. Prayers are an expression of devotion, for they transform the mind and help one find ease. Faith and devotion are thus an entry point for finding and engaging the mind and developing nondual awareness. The main thing is to see what devotion does to our mind-state and well-being. In *Light Comes Through*, Kongtrül Rinpoche offers a more general view of devotion that resonates deeply with my experience. There he wrote that realized beings are independent as practitioners, confident in the view of practice. They realize the true nature of mind that is unobstructed and unconfused, yet carry a profound sense of appreciation for the source of this awakening. Slowly, over time, I have come to understand this. At moments in the shrine room or shrine tent, I have felt overcome with appreciation for and devotion to this teacher and this path. In those moments, I "peer through the doors of devotion," as Dzongsar Khyentse Rinpoche put it in *Not for Happiness*.

For years, I have cultivated my devotion mostly through studio work. During many periods of intensive practice, I created visual records of my activities: sitting on the cushion, walking meditation, prostrations, reciting mantras, and prayers. Recently, I began to create a series of practice cards or *tsakli*. I first encountered the idea of artists creating hundreds of images in a series when studying the art of nineteenth-century Japanese artists Hokusai and Hiroshige, both of whom painted or printed one hundred views of Mount Fuji, views of Edo, and the work of one hundred poets. Artist and Naropa professor Robert Spellman inspired my first series of one hundred drawings of Ivydell, and later I painted 108 *Cantos for This Place*.

FIGURE 27

Tsakli are miniature Buddhist paintings, usually produced in sets of six to one hundred or more. Traditionally used in ritual empowerments and in the training of monastics, they can also be used to create mandalas, transmit teachings, and act as visualization aids or substitutes for ceremonial items. And they can be used to help a dying person through the process. Many subjects are depicted in *tsakli*—from deities and protectors to their various power attributes and appropriate offerings. Subjects are similar to thangkas but simplified due to their small size.

I am presently working on a set of 108 *tsakli* related to my Buddhist practice. The cards act as meditative aids for me. Beyond this, they have provoked further reflection about whether meditative wisdom is always associated only with on-the-cushion practice, or whether making and using images, either abstract or with forms, can be an expression of meditative wisdom.

FIGURE 28

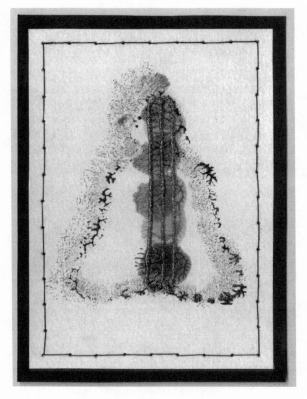

In his book *Old Path, White Clouds,* Thich Nhat Hanh tells a famous story of the Buddha. In it, the Buddha says that his teaching is neither dogma nor doctrine, but a method of experiencing reality. Like a finger pointing to the moon, it is not to be confused with the moon itself. While we make use of a finger to see the moon, someone who only looks at the finger will never see the actual moon. Put simply, I wonder if all art must always remain simply a pointer, like this proverbial finger?

In 2016, I saw artist Laurie Anderson's film *Heart of a Dog.* Some would say that it was a finger pointing to the moon, but for me it was a direct expression of meditative wisdom. I sat in the small, dark theater, mesmerized. On one level, the film is an extended meditation on the deaths of her beloved animal companion, her mother, and her husband, Lou Reed. Yet, *Heart of a Dog* offers its viewers pithy instructions for living and for meditation practice. The purpose of our days is to wake us up. A worthy goal is to live in the gap between thoughts because this is where one begins

to find luminous emptiness. Recognize everything as the play of your own mind. And life, she says near the film's end, "is a pilgrimage towards death and love." I left the theater in an altered, awake state. Anderson used a narrative method, not an abstract one, to express and evoke meditative wisdom.

There is, finally, something mysterious and ineffable about creativity. I believe that it is a dialogical process. Like an actual dialogue with another person, the creative process is unpredictable and often surprising, highly dependent upon context. Creativity entails interaction with materials and techniques in particular times and places, and each of these factors—materials, techniques, time and place—create their own kind of serendipity that is very difficult to describe.

I opened this book with a range of questions about what it means to be an artist and about how art might become an expression of your inner life and spiritual practice. I close it with an invitation to you to consider how creating art might become a pathway of awakening. May you find joy and wisdom as you traverse this path.

Appendix: A Manifesto

1. To contribute toward the future, the artist must have a compassion-ate spirit, keen intellect, and strong body, as well as developed inner vision and far-reaching outer sight. Keep your eye simultaneously on your next step and on the long horizon.

2. Cultivate stamina, for the artist's vocation is strenuous. It is not for everyone.

3. If you are an artist or aspire to become an artist, cultivate your eye-hand coordination by looking at the world and by representing what you experience.

4. Create your own challenges and follow through. Draw to give your self-reflection visual form.

5. Write to find out what you think. Unless you know what you think, you will always be subject to the will of others, including the media that so pervasively shape contemporary cultures.

6. Try to understand and articulate your motivations and reasons for believing and acting in particular ways. These are compelling reasons to write.

7. Read to find out about the worlds of others. Self-satisfied narcissism and ignorance have no place in the life of a serious artist today.

8. Read to inform and inspire your life, your writing, and your art.

9. The sustained multitasking and continuously interrupted attention of contemporary life often leave us with no time to think and with minds and bodies that are too fast for reading. Consider what you will do about this.

10. Remember that everything changes, always.

11. Carefully observe the processes of living, dying, and rebirth as they occur in the immediate environment. This is a profound spiritual practice, and it will affect every aspect of your being.

12. We make and remake our world through ritual.

13. Although you may be unaware of their presence in your life, both personal and collective rituals affect every aspect of your thought and action.

14. Rituals ground us in the present moment, while simultaneously signifying change.

15. All people, in all times, have created sacred space. Now it is time to treat the earth itself as sacred. Making art can be a vehicle for you to explore this.

16. Observe with awe the ineffable beauty and mystery of the world. It is your responsibility as an artist to translate this experience and communicate it to others.

17. Create a space, a studio of whatever size, in which to work. If you are itinerant, construct a tool kit and take it with you wherever you go.

18. Learn self-discipline. Although it does not guarantee greatness, showing up does mean that you have made time to create.

19. You will not find your own voice and vision unless you are present to yourself. Go to the studio regularly, wherever it is.

20. Explore the studio as a sacred space for solitude and meditation.

21. Consider what you hold as sacred and worthy of reverence and devotion.

22. If you have not done so already, initiate basic practices of caring for yourself. Explore the healing arts, from massage to alternative medicine. It is vital that you restore and heal your body as you cultivate your spiritual life.

23. Teachers and mentors can guide you, provide inspiration, and help to shape your vocation as an artist.

24. Ultimately, you must become your own teacher—astute, critical, and compassionate.

25. Training the mind has to do with developing new habits of openness and stillness.

26. We are already well trained in self-cherishing and ego-clinging. Observe what happens when you release these habits, even in small ways.

27. Always return to the practices of mindful attention, to observing the world as it presents itself. Discipline yourself rather than being disciplined by others. Establish a daily contemplative practice on five or six days a week.

28. Let your practice inform your art; let your art become a form of meditation.

29. Study the arts of various cultures across time. Find out what compelled people to create in other times and places.

30. Knowing about the past will aid you in dealing with the present. You cannot create the new in a vacuum. You may find particular cultural traditions emerging in surprising ways in your own work.

31. In your creative work, take risks. Do not abandon your own or others' traditions completely, but experiment and play with images and symbols to surprise yourself.

32. Use information and data to gain knowledge. Do not allow yourself to be seduced by information for its own sake. Wisdom will evolve as you grapple imaginatively with what you learn.

33. Inquire into the nature of reality, phenomenological and virtual. Examine the source of the forces that are shaping your experience as an artist, citizen, and individual connected with others.

34. Think deeply about who you are and who you want to become as an artist.

35. Articulate your values, for if you do not know your own ethical standpoint, as an artist you will always be subject to forces outside your control.

36. Creating art can both challenge and depict your values, resulting in new ways of knowing and being.

37. Affirm virtues, such as kindness and generosity, that will remain constant throughout your life. The idealism of such convictions will be tempered by your actual living, but they will provide a moral compass.

38. Enter into an apprenticeship with nature by paying attention to and observing the natural world.

39. Take the time to learn the lessons of the seasons, of water, of the growth cycles of plants, and of the habits of the animal world. The knowledge you gain from these activities will nourish your art.

40. Commit yourself wholeheartedly to your regular meditation and artistic practices. Do not be afraid of commitment, and do not get into the habit of procrastinating about your work. This is what it means to take your seat.

41. Consider breadth and depth. Explore the breadth of the arts and the breadth of your abilities, but let your ideas guide you toward the most appropriate vehicle. Work from the depths of your inner life.

42. Live your life as an art, for the place of art is in daily life.

43. Without connection to life as it is lived, art is meaningless or simply a commodity. Conversely, without art, life remains trivial and mundane.

44. Consider carefully the question of audience and how you will participate in the worlds of art. Determine for whom you make art and where it belongs.

45. Creativity is a dialogical process, like an authentic human conversation. You cannot script it, but it works best when you are attentive to mystery and serendipity.

References and Suggested Reading

Anderson, Laurie, writer and director. *Heart of a Dog.* DVD. New York: Canal Street Communications, 2015.

Arendt, Hannah. *The Human Condition.* Chicago: University of Chicago Press, 1958.

Audette, Anna Held, ed. and comp. *100 Creative Drawing Ideas.* Boston: Shambhala, 2004.

Azara, Nancy. *Spirit Taking Form: Making a Spiritual Practice of Making Art.* York Beach, ME: Red Wheel/Weiser, 2002.

Baas, Jacquelynn. *Smile of the Buddha: Eastern Philosophy and Western Art from Monet to Today.* Berkeley: University of California Press, 2005.

Baas, Jacquelynn, and Mary Jane Jacob, eds. *Buddha Mind in Contemporary Art.* Berkeley: University of California Press, 2004.

Bachelard, Gaston. *The Psychoanalysis of Fire.* Translated by Alan C. M. Ross. Boston: Beacon, 1964.

Bacon, Francis. *Essays, and The New Atlantis.* New York: Black, 1942.

Bakhtin, Mikhail M. *Art and Answerability: Early Philosophical Essays by M. M. Bakhtin.* Edited by Michael Holquist and Vadim Liapunov. Translation and notes by Vadim Liapunov. Supplement translated by Kenneth Brostrom. University of Texas Press Slavic Series 9. Austin: University of Texas Press, 1990.

———. *Toward a Philosophy of the Act.* Translation and notes by Vadim Liapunov. Edited by Michael Holquist and Vadim Liapunov. University of Texas Press Slavic Series 10. Austin: University of Texas Press, 1993.

Baldwin, James. *Nobody Knows My Name: More Notes of a Native Son.* New York: Dial, 1961.

Bambara, Toni Cade. *The Salt Eaters.* New York: Random House, 1980.

Beér, Robert. *The Encyclopedia of Tibetan Symbols and Motifs.* Boston: Shambhala, 1999.

Bell, Catherine M. *Ritual Theory, Ritual Practice.* New York: Oxford University Press, 1992.

Berensohn, Paulus. *Finding One's Way with Clay: Pinched Pottery and the Color of Clay.* New York: Simon & Schuster, 1972.

Boyce, Mary. *A History of Zoroastrianism.* Vol. 1, *The Early Period.* 3rd impression with corrections. Leiden: Brill, 1996.

Butler, Katy. *Knocking on Heaven's Door: The Path to a Better Way of Death.* New York: Scribner, 2013.

Campbell, Joseph. *The Masks of God.* Vol. 4, *Creative Mythology.* New York: Viking, 1968.

Chandrakirti, and Jamgön Mipham. *Introduction to the Middle Way: Chandrakirti's Madhyamakavatara.* Translated by the Padmakara Translation Group. Boston: Shambhala, 2004.

Chödrön, Pema. *Comfortable with Uncertainty: 108 Teachings.* Compiled and edited by Emily Hilburn Sell. Boston: Shambhala, 2002.

———. *No Time to Lose: A Timely Guide to the Way of the Bodhisattva.* Edited by Helen Berliner. Boston: Shambhala, 2005.

———. *Start Where You Are: A Guide to Compassionate Living.* Boston: Shambhala, 1994.

———. *When Things Fall Apart: Heart Advice for Difficult Times.* Boston: Shambhala, 1997.

———. *The Wisdom of No Escape and the Path of Lovingkindness.* Boston: Shambhala, 1991.

Cole, Susan Guettel. *Theoi Megaloi: The Cult of the Great Gods at Samothrace.* Etudes préliminaires aux religions orientales dans l'Empire romain 96. Leiden: Brill, 1984.

Daly, Mary. *Beyond God the Father: Toward a Philosophy of Women's Liberation.* Boston: Beacon, 1973.

———. *Gyn/Ecology: The Metaethics of Radical Feminism.* Boston: Beacon, 1978.

———. *Websters' First New Intergalactic Wickedary of the English Language.* Conjured in Cahoots with Jane Caputi. Boston: Beacon, 1987.

Descartes, René. *Discourse on Method; and, Meditations on First Philosophy.* Translated by Donald A. Cress. Indianapolis: Hackett, 1993.

Dillard, Annie. *The Writing Life.* New York: Harper, 1989.

Dilley, Barbara Lloyd. *This Very Moment: Teaching, Thinking, Dancing.* Boulder: Naropa University Press, 2015.

Dzogchen Ponlop, Rinpoche. *Penetrating Wisdom: The Aspiration of Samantabhadra.* Ithaca, NY: Snow Lion, 2006.

Edwards, Betty. *Drawing on the Right Side of the Brain: A Course in Enhancing Creativity and Artistic Confidence.* Los Angeles: Tarcher, 1979.

Eliade, Mircea. *The Myth of the Eternal Return, or, Cosmos and History.* Translated by Willard Trask. Bollingen Series 46. Princeton: Princeton University Press, 1954.

———. *Rites and Symbols of Initiation: The Mysteries of Birth and Rebirth.* Translated by Willard R. Trask. Dallas: Spring, 1994.

Emerson, Ralph Waldo. "Self-Reliance." https://www.gutenberg.org/files/16643/16643-h/16643-h.htm#SELF-RELIANCE/.

Fischer, Norman. *Training in Compassion: Zen Teachings on the Practice of Lojong.* Boston: Shambhala, 2013.

Forster, E. M. "The Machine Stops." In *The Eternal Moment, and Other Stories.* New York: Harcourt, Brace, 1928.

Geertz, Clifford. *The Interpretation of Cultures: Selected Essays.* New York: Basic Books, 1973.

———. *Local Knowledge: Further Essays in Interpretive Anthropology.* New York: Basic Books, 1983.

Gnoli, Gherardo. *Zoroaster's Time and Homeland: A Study on the Origins of Mazdeism and Related Problems.* Series minor—Istituto universitario orientale, Seminario di studi asiatici 7. Naples: Istituto universitario orientale, 1980.

Gsaenger, Hans. *Mysterienstätten der Menschheit: Die Externsteine.* Frieburg: Die Kommenden, 1977.

Hardy, G. H. *A Mathematician's Apology*. Cambridge: The University Press, 1941.

Hassan, Ihab. "Prometheus as Performer: Towards a Posthumanist Culture?" In *Performance in Postmodern Culture*, edited by Michael Benamou and Charles Caramella, 201–17. Madison, WI: Coda, 1977.

Hayles, N. Katherine. *How We Became Posthuman: Virtual Bodies in Cybernetics, Literature, and Informatics*. Chicago: University of Chicago Press, 1999.

Haynes, Deborah J. *Art Lessons: Meditations on the Creative Life*. Boulder: Westview, 2003.

———. *Bakhtin and the Visual Arts*. Cambridge Studies in New Art History and Criticism. Cambridge: Cambridge University Press, 1995.

———. *Bakhtin Reframed*. Contemporary Thinkers Reframed Series. London: I. B. Tauris, 2013.

———. *Book of This Place: The Land, Art & Spirituality*. Eugene, OR: Pickwick Publications, 2009.

———. *Spirituality and Growth on the Leadership Path: An Abecedary*. Eugene, OR: Pickwick Publications, 2012.

———. *The Vocation of the Artist*. New York: Cambridge University Press, 1997.

Haynes, Deborah J., et al. "The Blue Pearl: The Efficacy of Teaching Mindfulness Practices to College Students." *Buddhist Christian Studies* 33 (2013) 63–82.

Heim, Michael. *The Metaphysics of Virtual Reality*. New York: Oxford University Press, 1993.

———. *Virtual Realism*. New York: Oxford University Press, 1998.

Henri, Robert. *The Art Spirit*. Compiled by Margery Ryerson. New York: Lippincott, 1923.

Hoblitzelle, Olivia Ames. *Aging with Wisdom: Reflections, Stories, and Teachings*. Rhinebeck, NY: Monkfish, 2017.

———. *Ten Thousand Joys & Ten Thousand Sorrows: A Couple's Journey through Alzheimer's*. New York: Tarcher/Penguin, 2010.

Hughes, Langston. *Selected Poems of Langston Hughes*. New York: Knopf, 1959.

Hurston, Zora Neale. *Their Eyes Were Watching God: A Novel*. Philadelphia: Lippincott, 1937.

Johnson, Will. *The Posture of Meditation: A Practical Manual for Meditators of All Traditions*. Boston: Shambhala, 1996.

Karr, Mary. *The Liar's Club: A Memoir*. Rockland, MA: Wheeler, 1995.

Keats, John. "On Negative Capability: Letter to George and Thomas Keats." In *The Letters of John Keats*, edited by H. E. Rollins, 1:93–94. 2 vols. Cambridge: Harvard University Press, 1958.

Khyentse, Jamyang. *Not for Happiness: A Guide to the So-Called Preliminary Practices*. Boston: Shambhala, 2012.

Klee, Paul. *The Thinking Eye*. Edited by Jürg Spiller. Translated by Ralph Manheim. Woodstock, NY: Overlook, 1992.

Klein, Anne Carolyn. *Meeting the Great Bliss Queen: Buddhists, Feminists, and the Art of the Self*. Boston: Beacon, 1995.

Kongtrül, Dzigar, Rinpoche. *The Intelligent Heart: A Guide to the Compassionate Life*. Boulder: Shambhala, 2016.

———. *It's Up to You: The Practice of Self-Reflection on the Buddhist Path*. Boston: Shambhala, 2005.

———. *Light Comes Through: Buddhist Teachings on Awakening to Our Natural Intelligence*. Boston: Shambhala, 2008.

———. *Natural Vitality: The Paintings of Kongtrül Jigme Namgyel.* Exhibition catalog. New York: Tibet House, 2007.

———. *Training in Tenderness: Buddhist Teachings on Tsewa, the Radical Openness of Heart That Can Change the World.* Boulder: Shambhala, 2018.

———. *Uncommon Happiness: The Path of the Compassionate Warrior.* Compiled and edited by Marcia Binder Schmidt. Boudhanath, Nepal: Rangjung Yeshe, 2009.

Kongtrül, Jamgon. *The Great Path of Awakening: The Classic Guide to Lojong, A Tibetan Buddhist Practice for Cultivating the Heart of Compassion.* Translated by Ken McLeod. Shambhala Classics. Boston: Shambhala, 2005.

Kornfield, Jack. *A Path with Heart: A Guide through the Perils and Promises of the Spiritual Life.* New York: Bantam, 1993.

Lehmann, Karl. *Samothrace: A Guide to the Excavations and the Museum.* 5th ed. rev. and enl. Locust Valley, NY: Augustin, 1983.

Mackenzie Stewart, Jampa, comp. and ed. *The Life of Longchenpa: The Omniscient Dharma King of the Vast Expanse.* Ithaca, NY: Snow Lion, 2013.

Maitreya, Arya. *Buddha Nature: The Mahayana Uttaratantra Shastra.* Commentary by Jamgön Kongtrül Lodrö Thayé. Translated by Rosemarie Fuchs. Ithaca, NY: Snow Lion, 2000.

Marcel, Gabriel. *Homo Viator: Introduction to a Metaphysic of Hope.* Translated by Emma Craufurd. Chicago: Regnery, 1951.

Marshall, Paule. *Praisesong for the Widow.* New York: Putnam, 1983.

Mattis Namgyel, Elizabeth. *The Logic of Faith.* Boulder: Shambhala, 2018.

———. *The Power of an Open Question: The Buddha's Path to Freedom.* Boston: Shambhala, 2010.

McBride, James. *The Color of Water: A Black Man's Tribute to His White Mother.* New York: Riverhead, 1996.

McDowell, Robert. *Poetry as Spiritual Practice: Reading, Writing, and Using Poetry in Your Daily Rituals, Aspirations, and Intentions.* New York: Free Press, 2008.

Miles, Margaret R. "Becoming Answerable for What We See." *Journal of the American Academy of Religion* 68 (2000) 471–85.

———. *Image as Insight: Visual Understanding in Western Christianity and Secular Culture.* Boston: Beacon, 1985.

———. *The Long Goodbye: Dementia Diaries.* Eugene, OR: Cascade Books, 2017.

———. *Reading for Life: Beauty, Pluralism and Responsibility.* New York: Continuum, 1997.

———. *The Word Made Flesh: A History of Christian Thought.* Malden, MA: Blackwell, 2005.

Morrison, Toni. *Beloved.* New York: Knopf, 1987.

Morson, Gary Saul, and Caryl Emerson. *Mikhail Bakhtin: Creation of a Prosaics.* Stanford: Stanford University Press, 1990.

Nagarjuna. *The Root Stanzas on the Middle Way: Mūlamadhyamaka-kārikā.* Translated by the Padmakara Translation Group. Le Plantou, France: Padmakara, 2008.

Nhat Hanh, Thich. *The Heart of the Buddha's Teaching: Transforming Suffering into Peace, Joy & Liberation.* New York: Broadway, 1999.

———. *The Miracle of Mindfulness: An Introduction to the Practice of Meditation.* Boston: Beacon, 1987.

———. *Old Path, White Clouds: Walking in the Footsteps of the Buddha.* Berkeley: Parallax, 1991.

Nicolaides, Kimon. *The Natural Way to Draw: A Working Plan for Art Study*. Boston: Houghton Mifflin, 1941.

Ozeki, Ruth. *A Tale for the Time Being*. New York: Viking, 2013.

———. "Confessions of a Zen Novelist." *Buddhadharma*, February 2013. http://www. ruthozeki.com/other-writing/2014/1/5/confessions-of-a-zen-novelist/.

Patrul, Rinpoche. *The Words of My Perfect Teacher*. Rev. ed. Translated by the Padmakara Translation Group. Boston: Shambhala, 1998.

Rabjam, Longchen. *The Practice of Dzogchen*. Translated by Tulku Thondup. Edited by Harold Talbott. 3rd ed. Buddhayana Series 3. Ithaca, NY: Snow Lion, 2002.

Rahula, Walpola. *What the Buddha Taught*. Rev. ed. 2nd and enl. ed. New York: Grove Weidenfeld, 1974.

Ray, Reginald A. *Indestructible Truth: The Living Spirituality of Tibetan Buddhism*. Boston: Shambhala, 2000.

———. *Secret of the Vajra World: The Tantric Buddhism of Tibet*. Boston: Shambhala, 2001.

Read, Herbert. "Toward a Duplex Civilization." In *Selected Writings: Poetry and Criticism*, 336–57. New York: Horizon, 1964.

Richards, Mary Caroline. *Centering in Pottery, Poetry, and the Person*. Middletown, CT: Wesleyan University Press, 1964.

———. *The Crossing Point: Selected Talks and Writings*. Middletown, CT: Wesleyan University Press, 1973.

———. *Opening Our Moral Eye: Essays, Talks & Poems Embracing Creativity & Community*. Edited by Deborah J. Haynes. Hudson, NY: Lindisfarne, 1996.

Rosenberg, Larry, with David Guy. *Breath by Breath: The Liberating Practice of Insight Meditation*. Boston: Shambhala, 1999.

———. *Living in the Light of Death: On the Art of Being Truly Alive*. Boston: Shambhala, 2001.

Shantarakshita, and Jamgön Mipham. *The Adornment of the Middle Way: Shantarakshita's Madhyamakalandkara*. Translated by the Padmakara Translation Group. Boston: Shambhala, 2010.

Shantideva. *The Way of the Bodhisattva: A Translation of the Bodhicharyāvatāra*. Translated by the Padmakara Translation Group. Boston: Shambhala, 2003.

Shulman, Alix Kates. *A Good Enough Daughter: A Memoir*. New York: Schocken, 1999.

Simmer-Brown, Judith. *Dakini's Warm Breath: The Feminine Principle in Tibetan Buddhism*. Boston: Shambhala, 2001.

Simon, John F., Jr. *Drawing Your Own Path: 33 Practices at the Crossroads of Art and Meditation*. Berkeley: Parallax, 2016.

Spirn, Anne Whiston. *The Language of Landscape*. New Haven: Yale University Press, 1998.

Stanley, Liz. *The Auto/biographical I: The Theory and Practice of Feminist Auto/biography*. Manchester: Manchester University Press, 1992.

Suzuki, Shunryu. *Zen Mind, Beginner's Mind: Informal Talks on Zen Meditation and Practice*. Boston: Weatherhill, 2009. First published 1970 by Walker/Weatherhill.

Taylor, Mark C., and Esa Saarinen. *Imagologies: Media Philosophy*. London: Routledge, 1994.

Thayé, Jamgön Kongtrül Lodrö. *Creation & Completion: Essential Points of Tantric Meditation*. Translated by Sarah Harding. Boston: Wisdom, 1996.

————. *The Treasury of Knowledge: Book Six, Part Four: Systems of Buddhist Tantra, The Indestructible Way of Secret Mantra.* Translated by Kalu Rinpoché Translation Group. Ithaca, NY: Snow Lion, 2005.

Trungpa, Chögyam. *Cutting through Spiritual Materialism.* Boston: Shambhala, 1973.

————. *Dharma Art.* Edited by Judith L. Lief. Dharma Ocean Series. Boston: Shambhala, 1996.

————. *Meditation in Action.* Clear Light Series. Berkeley: Shambhala, 1969.

Turkle, Sherry. *Life on the Screen: Identity in the Age of the Internet.* New York: Simon & Schuster, 1995.

Walker, Alice. *The Color Purple.* New York: Pocket Books, 1982.

Williams, Raymond. *Keywords: A Vocabulary of Culture and Society.* Rev. ed. New York: Oxford University Press, 1983.

Willson, Martin, and Martin Brauen, eds. *Deities of Tibetan Buddhism: The Zürich Paintings of the Icons Worthwhile to See.* Boston: Wisdom, 2000.

Wolfe, Tom. *Electric Kool-Aid Acid Test.* New York: Farrar, Straus & Giroux, 1968.

Index

About the Author

Deborah J. Haynes is Professor Emerita of Art and Art History at the University of Colorado Boulder. She has BFA and MFA degrees in ceramics from the University of Oregon, the MTS degree from Harvard Divinity School, and a PhD from Harvard University in the Study of Religion and Art History. She taught art history and theory, plus graduate seminars in studio practice, at Washington State University and University of Colorado Boulder from 1991–2013, and served as a program director or department chair for more than fourteen years. Haynes is the author of numerous articles on philosophy of art, as well as six books: *Bakhtin and the Visual Arts* (Cambridge, 1995); *The Vocation of the Artist* (Cambridge, 1997); *Art Lessons: Meditations on the Creative Life* (Westview, 2003); *Book of This Place: The Land, Art, and Spirituality* (Pickwick/Wipf & Stock, 2009); *Spirituality and Growth on the Leadership Path: An Abecedary* (Pickwick/Wipf & Stock, 2012); and *Bakhtin Reframed* (I. B. Tauris, 2013). Her work as an artist includes carving marble and mixed media drawing and painting on paper. For more information, see www.DeborahJHaynes.com.